D1595749

AUG - - 2009

DATE DUE			

DEMCO

GHOSTS OF THE PEE DEE

TALLY JOHNSON

Haunted
America

Published by Haunted America
A Division of The History Press
Charleston, SC 29403
www.historypress.net

First published 2009

Manufactured in the United States

ISBN 978.1.59629.626.8

Library of Congress Cataloging-in-Publication Data

Johnson, Talmadge.
Ghosts of the Pee Dee / Tally Johnson.
p. cm.
Includes bibliographical references.
ISBN 978-1-59629-626-8
1. Ghosts--South Carolina--Pee Dee Region. 2. Pee Dee Region (S.C.)--History.
I. Title.
BF1472.U6J653 2009
133.109757'8--dc22
2009007729

This book is dedicated to the memory of my late mother-in-law, Anita Wylie, and paternal grandfather, O.J. Johnson. I love and miss you both.

CONTENTS

AUTHOR'S NOTE

All accounts and events in this book are related as they occurred to the people involved. The author has sought to verify all personal accounts with other sources, but in some cases this was not possible. The author also states that the events in this book are true to the best of his knowledge. Any location at which the author failed to have an experience may still be haunted, but some people are luckier than others. Please do not trespass or vandalize sites found in this book or in any other collection of ghost lore. You aren't funny and you are committing a crime, not to mention making the jobs of serious researchers like myself that much harder. Enjoy the book but do so responsibly.

ACKNOWLEDGEMENTS

I would like to acknowledge the love and support of my parents, Mike Johnson and Doris Wilson, as well as that of my friends, whose patience, support and willingness to be dragged all over South Carolina at a moment's notice were tested at various times over the writing and researching of this book and the other two as well. And as always, I want to thank my wife, Rachel, for her love, support and understanding. A special note of thanks to my maternal grandparents, Carl and Doris Betts Wilson, for the support and enthusiasm that they have shown me from the first idea for this series of books until now. To anyone left unnamed, thanks all the same.

INTRODUCTION

During book signings and storytelling appearances, I often get asked, "Do you believe in ghosts?" I have to reply that I do, since I have seen them in almost every county of the state. I haven't seen one in Jasper County yet, but it's just a matter of time. I view ghost stories as a way to learn the hidden history of a place. The stories of yesterday that in today's media would be in the *National Enquirer* are the ghost stories that we tell each other for a shiver. I also get asked why I would include ghost stories from Richland, Dorchester and Berkeley Counties in a book about the Pee Dee and Sand Hills regions. My response is, "Where else would you read them?" Few of the Charleston ghost story books embrace Berkeley and Dorchester. Anyone who has spent time at Lake Marion or Lake Moultrie would agree that those areas have more in common with the Pee Dee than with the Lowcountry. Richland County is included because I still had stories to tell even after covering some of them in my previous book, *Ghosts of the South Carolina Midlands*.

Finally, I also get asked if I am going to write any more books or if I am going to write a book on the ghosts of the Grand Strand and Lowcountry. I especially get the latter question from family and friends, who are more interested in road trips than ghosts. Well, honestly, that's up to you. If this book sells well enough that the

publisher wants more, I'll write one. Or if you tell The History Press that you and all ten thousand of your friends want to read my next book, I'll probably write one. My personal feeling is that I won't cover the South Carolina coast anytime soon, barring a large number of requests and begging from my publisher. I mean, Terrance Zepke, Nancy Roberts, Margaret Rhett Martin, Nancy Rhyne, Geordie Buxton, Elizabeth Huntsinger Wolf and Blanche Floyd are some tough acts to follow. As it is now, I, like Isaac Newton, have seen as far as I have by standing on the shoulders of giants. I'm none too sure that I want to get under their feet. In any case, I do hope that you have as much fun reading this book as I did researching it. I got to go to some of the most history-drenched spots in inland South Carolina and meet some of the best public servants the state has in its corner. But remember: if you decide to follow in my footsteps, be careful, be respectful and obey all laws and signage. Otherwise, you deserve whatever happens.

BERKELEY COUNTY

B erkeley County is located in the southern central part of South Carolina and is surrounded by Charleston, Georgetown, Williamsburg, Clarendon, Orangeburg and Dorchester Counties. The present county was established in 1882 from Charleston County, though earlier parishes such as St. James Goose Creek, St. Thomas, St. Denis, St. Johns Berkeley and St. Stephens occupied the same territory. The county was named for John and William Berkeley, two of the Lords Proprietor, as well as the short-lived original 1682 county of the same name. From 1786 until 1882, the territory of Berkeley County was part of Charleston County. From the early part of the first century until about 1725, the area was home to several thriving native cultures. Both the Westo and Yamasee Wars ended any threat to English settlement, with Berkeley County being the site of one fort during the Westo War and five during the Yamasee. After its reestablishment, Berkeley County lost territory to Dorchester County. Due to its proximity to Charleston and its role as a center of recruitment for Francis Marion, the Revolutionary general known as the "Swamp Fox" and a native of Berkeley County, the county was the site of twelve actions during the Revolution. Besides the impact the Revolution had in the county, it had even more on some natives. Henry Laurens

was president of the Continental Congress from 1777 to 1778 and then minister to Holland, a prisoner in the Tower of London and a peace commissioner following his exchange for Lord Cornwallis.

No actions are recorded in the county during the Civil War, but it was the construction site for the Confederate semisubmersible *Little David* in 1863. John Gaillard—who served as president pro tempore under President James Madison while in the U.S. Senate from 1805 to 1826—was born in Berkeley County. Due to the death of Vice President Elbridge Gerry in November 1814, and until the end of Madison's term on March 3, 1817, Gaillard was next in line to the presidency. L. Mendel Rivers, a longtime congressman known as the "Serviceman's Best Friend," was also born in Berkeley County. Mepkin Abbey—once the home of the Laurens family, of Revolutionary fame, as well as the former summer home of Henry and Clare Boothe Luce and now the center of a Trappist monastery—is located near Goose Creek. The bodies of Henry and John Laurens and Henry and Clare Luce are interred at the cemetery. Berkeley County was the home of Daniel Chamberlain, South Carolina's last carpetbagger governor, prior to his election. Berkeley County is home to part of Lake Marion and all of Lake Moultrie.

MEDWAY PLANTATION

The original house at Medway Plantation was built circa 1686 by John D'Arsens a mere sixteen years after the first permanent English settlement at what was then Charles Towne. In some records, this gentleman is referred to as Jan Van Arrsen. However, by 1705 the house had burned down and was rebuilt by Edward and Elizabeth Hyrne. Over the more than three intervening centuries, several owners have come and gone, including some notable South Carolina names such as Stoney, Ball, Durant, Legendre and Fripp.

During the ownership by the Stoney family, a brickyard was in operation alongside the rice fields that is reputed to have supplied bricks for Fort Sumter. The Stoney family is also thought to have been responsible for the remains of a racetrack on the property.

As one would expect from a site so long inhabited, there are several ghosts present. Jan Van Arrsen (or John D'Arsens) is rumored to appear before the fireplace in the south bedroom, smoking a pipe. Perhaps he returns to enjoy the home that he died too soon in life to enjoy or to remind visitors of his pride of place, since his grave is unmarked and unrecorded. There is some dispute as to the identity of the other ghost at Medway. Most accounts claim that she is the young wife of a long-forgotten owner of the plantation who died in a hunting accident soon after their marriage. She died shortly thereafter from the shock of seeing her husband's body on a makeshift stretcher. She appears at the north window, anxiously scanning the grounds for her beloved's return. Some only hear the faint rustle of her gown while she waits. I think this could be Mary Hyrne, who may haunt Yeoman's (or Yeamans) Hall in North Charleston, according to many online sources. I have not found any independent verification of this haunting, and I believe that, over the years, Miss Hyrne's ghost has been moved from Medway to Yeoman's Hall in the mind of the public. Sadly, I have not met either Jan Van Arrsen or the unfortunate bride, as Medway is private property. Perhaps others will have better luck.

DAVE PEIGLER STILL ROAMS ST. STEPHENS CHURCHYARD

St. Stephens Episcopal Church was built in 1768, and it still stands and is an active church, despite services not being held in the building from 1808 to 1932. St. Stephens is a National Historic Landmark, so treat it with the respect that it is due. The one known

ghost is that of a local Tory, horse thief and burglar named Dave Peigler. Mr. Peigler was fond of raiding plantations while the Patriot owners were off fighting Tory partisans and British regulars during the Revolution. However, he was captured when an intended target named Captain Theus was home. Despite a brief escape, Peigler was hanged in the churchyard of St. Stephens. Now, you may hear the creak of a rope on wood or even see a figure staggering through the cemetery with a bottle in one hand and a gun in the other. If you do and you also see a rope around this figure's neck, you have seen Dave Peigler. On my visit, I heard the unmistakable creak of hemp on wood but saw nothing. The sound was enough to encourage a hasty retreat.

RICE HOPE PLANTATION

Rice Hope Plantation was built by the Huger family about 1696. The plantation was owned by the Harleston and Read families from early in the nineteenth century until about 1875. In 1840, the original home burned down and was rebuilt. In the mid-1920s, John Frelinghuysen—whose claim to having been a U.S. senator from New Jersey cannot be verified by the Congressional Biographical Directory—renovated the house but sold it prior to 1949. However, there was a Joseph Frelinghuysen Sr. who did serve in the U.S. Senate representing New Jersey in the 1920s. There may be some confusion over names, but that is just speculation. In the last thirty years, the property has served as a school for unruly boys, an art school and now serves as a bed-and-breakfast. According to the current owner, Lou Edens, a ghost there is none other than the "mammy" of the famed Little Mistress Chicken of Strawberry Chapel fame, who we will meet later. This claim may not be as far-fetched as it appears, since at least one past owner of Rice Hope served as caretaker for Strawberry Chapel.

The focal point of the haunting seems to be the Heron Room, overlooking the Cooper River. According to published accounts, the traumatized child in question was comforted in this room by her grandmother following an ordeal. Voices have been heard, doors open and close without human assistance and a rocking chair has been known to rock while empty. The rocker has been removed due to space issues but is placed in the room upon request. My best efforts to visit Rice Hope have been stymied by circumstance, but Ms. Edens assures me that the ghost is still present and waiting for guests. I hope to convince my wife to spend our anniversary there—and yes, we'll have the rocker placed in the room, just in case.

PONTOUX OF PARNASSUS

The former Parnassus Plantation was located on Back Creek on what are now the grounds of the Charleston Naval Weapons Station. The plantation was established by Zachariah Villepontoux by 1701. Monsieur Villepontoux provided bricks and tiles for several Lowcountry churches, including Pompion Hill and St. Michael's in Charleston. By 1842, the property belonged to the Tennent family, who held it until they abandoned it in 1865. Afterward, the house fell into ruin and was looted for building materials. A large oak on the grounds was used as part of the cryptogram in the fictional *Treasure of Peyre Gaillard*, and this sadly led to the dynamiting of several stumps on the property by treasure hunters.

A spring on the site is the focal point of the haunting. It is reputed to be haunted by a former slave named Pontoux, who serves as the protector of the house, guarding it from mischief. He is supposed to protect the family graveyard as well. An online account states that marines were called out to the spring several times to pursue unauthorized visitors, but to no avail. Naturally, in this post–9/11 age, I could not get permission to visit the

site. I feel sure that Pontoux is still there, though he lacks as a protector.

SPEAKING OF LITTLE MISTRESS CHICKEN...

The ghost town of Childsbury passed into memory in the late 1700s following a malaria outbreak. The town, founded by James Child in 1707 with French Huguenots, was home to a Chapel of Ease established in 1725 known as Strawberry Chapel. The only thing besides the earthquake-ravaged chapel building that remains of Childsbury is the story of Little Mistress Chicken. About 1750, Catherine Chicken was sent to board with a Monsieur Dutarque while attending school in Childsbury. Catherine was the granddaughter of James Child, the stepdaughter of a member of the prominent Ball family and a descendant of the namesake of Chicken's Fort, site of a skirmish during the 1715–16 Yamasee War. One day, Catherine wandered off, as children are prone to do at times. When he found her, Dutarque punished her by tying her to a tombstone in the chapel graveyard. I honestly believe that he meant to release her after an hour or two, but she was left there overnight. Early the next morning but before sunrise, a passing slave heard her cries and returned her to her mother. I doubt one part of the story actually occurred: the idea that the slave lighting his way with a makeshift jack-o-lantern caused more trauma for the child. However, Dutarque was run out of town, if you believe the printed versions, riding backward on a mule, spared being either tarred and feathered or lynched by the kind words of his former student. Some versions add his wife to the tale; surprisingly, the wife is not cruel, just inattentive.

Following her ordeal, Catherine Chicken bore the marks of it on her face. Her portraits show drooping lips and eyes that are either described as grave or cast to the side, as if they expect pursuit.

Despite these imperfections, she made a good marriage into the renowned Simons family.

Strawberry Chapel still stands and the cemetery is still there. Four times a year, services are held in the empty building. Daytime visits are allowed, but the area is well patrolled by the police and no entry into the chapel itself is allowed without permission; nighttime visits are also discouraged. On my one daytime visit to the site, I felt a very real sense of sadness and regret while I walked through the cemetery. I believe I heard a faint childish voice, but that could have been just wildlife and an active imagination. Others have reported seeing the figure of a young girl running through the cemetery just before dark. The site is worth a visit, whether you have any paranormal experiences or not, due to the history of the chapel alone.

WAMPEE'S GHOSTS WAIT FOR GUESTS STILL

The former Wampee Plantation House now serves as the Wampee Conference Center for Santee Cooper, also known as the South Carolina Public Service Authority. Santee Cooper is responsible for the construction of both Lake Marion (the largest lake in South Carolina) and Lake Moultrie (the third largest lake in the state), where Wampee House is located. However, life at Wampee Plantation long predates both the lake by which it stands and even white settlement in South Carolina. The Indian mounds located on the property date prior to AD 1500. As you may know, the first permanent English settlement in South Carolina only dates to 1670. The plantation proper dates to 1696, and the current house dates back to 1822. However, the haunting dates back to the earliest days of white settlement and may be related to warfare between the existing native communities and the new arrivals.

According to local lore, the most commonly seen ghost at Wampee House was the wife of a Wampee warrior who fell alongside her husband in battle with the whites. Legend has it that the Wampee warriors who fell still haunt the area. I personally think that she fell victim to smallpox or another imported ailment. Regardless, she has been seen in every room of the house and all over the grounds. Her remains were apparently disturbed during excavations of the one of the nearby Indian mounds by the Charleston Museum some years ago. Her appearance is striking, as she wears slippers and a blue chiffon gown and has been described as having a porcelain face. Some accounts claim that the gown is made out of the water hyacinths for which the Wampees were possibly named. Her body was found intact and in a crouched position, though other burials in the mounds were of cremated remains.

Other incidents at Wampee House have led some witnesses to think that she is not alone. One of the bedrooms is home to a cold spot. Tiny white lights have been seen on the porch and in the woods along the drive when fireflies have not been in season. Doors have been heard to open and close, and lights have been seen in the windows when the center has not been in use. Objects have moved from room to room. A figure of a small girl has been seen in an upstairs bedroom looking out over the grounds for someone or something, though some suggest that she is the same spirit as the Indian maiden mentioned above. A face seen by a visitor hovering over one of the beds may be related to a reputed river pirate who was waylaid near Stony Landing.

My encounter at Wampee House occurred after the property had closed. In the dusk, I drove away from the house, keeping both eyes out for deer. I saw a flash of blue dart between two pines in an instant. After recovering my wits, I stopped and looked for the heron that I thought had flown by me. The woods were empty of any color but the rapidly approaching darkness. Not wanting to risk getting turned around, I returned to the modern world of

the interstate and headed home. I hope my next visit will lead to a longer stay with the Wampee maiden.

QUIMBY BRIDGE: DOES IT STILL ECHO WITH HOOFBEATS?

The skirmish at Quimby Bridge was sparked by the British burning of Biggin Church. It also marked one of the few occasions when Generals Sumter, Marion and "Light Horse" Harry Lee were present on the field together. On July 17, 1781, after a running gunfight during the chase, the British had set up a defensive position near Quimby Bridge on Thomas Shubrick's plantation. Marion and Lee decided to leave the British alone, but General Sumter ordered his infantry to attack. It failed, with heavy American losses. For decades after the battle, a heavy rain would send bones from the common grave located near the battle into the creek. Shortly afterward, reports of headless British troops riding over the bridge began.

Of course, after finding this story, I had to check it out. So I drove to the Ralph Hamer Boat Landing, near Huger, while en route to other Berkeley County sites. Just before dusk, I parked and walked over to the bridge. I would recommend only visiting the site in the fall or winter, due to snakes and vegetation. After a twenty-minute wait, it became clear that I was not going to hear anything extraordinary. However, I do think that the site has some potential and is certainly atmospheric enough to be haunted. I look forward to my next trip down.

CHESTERFIELD COUNTY

C hesterfield County was founded in 1785, is one of South Carolina's original counties and has maintained its boundaries intact since that date. It is bordered by Lancaster, Kershaw, Lee, Darlington and Marlboro Counties and by the state of North Carolina. It was named for Philip Stanhope, the fourth Earl of Chesterfield, who was active in British politics and letters during the county's first settlement. The native presence in the area spanned from 5000 BC until about 1760. Chesterfield County was the site of a "camp of repose" for General Greene's forces during the Revolution and was also the site of one battle. On November 19, 1860, the first call for secession in a public meeting was made at the Chesterfield County Courthouse. John A. Inglis of Cheraw was in attendance. He later introduced the resolution for South Carolina to secede. Inglis was also named the chairman of the committee that wrote the document for the state's secession. During the occupation of Cheraw in 1865, the courthouse and nearly all public records were burned. The first Confederate monument was erected in the churchyard of St. David's Church in 1867. Noah Knight, a recipient of the Congressional Medal of Honor in the Korean War, was a native of McBee, South Carolina. Van Lingle Mungo, a right-handed baseball pitcher who played for the Major League

Brooklyn Robins-Dodgers and New York Giants, was a native and was named after the grandfather-in-law of a co-worker of mine. Mungo's career spanned from 1931 to 1945, and he finished with a 120–115 won-lost record with a 3.47 earned run average. Mungo was a member of the 1934 and 1937 National League All-Star teams. William Pollock, U.S. senator from South Carolina, was also from Chesterfield County.

CAPTAIN BLAKENEY'S FAMILY CEMETERY: DO THE GHOSTS THERE STAND AT ATTENTION?

The story of this cemetery's namesake is fascinating. Captain John Blakeney was born in Ireland about 1732 and arrived in the American colonies about 1753. He moved to what is now Chesterfield County in 1760. His future military prowess can be inferred from his descent from one of the heroes of the first British Empire, Baron William Blakeney, the commander and lieutenant governor of Minorca in the Seven Years' War and widely known as the defender of Stirling Castle in Scotland during Bonnie Prince Charlie's Jacobite rebellion in 1745. Upon John Blakeney's arrival in what was then the Cheraw District, he became politically and socially active. He served as an overseer of the poor of the district and as a vestryman of St. David's Parish. With the coming of resistance to British rule, he was elected to the Provincial Congress of South Carolina in 1775, continuing in that capacity even after his appointment as a captain of militia serving under Colonel Lemuel Benton and General Francis Marion for the duration of the war. Three of his sons served with him in the Revolution. Captain Blakeney died in 1832 at one hundred years of age, having outlived at least two of his sons.

According to sources and local legend, if you visit the Blakeney family cemetery at night you may see members of the family

moving about the stones. I have my doubts about online versions of the tales due to the fact that they claim that the family is from the Civil War era, though most of the family's fame dates to the Revolution. However, the fact that there is no ritual of headlight flashing or horn blowing to summon the spirits does lend it a bit more credence in my opinion. The cemetery is located near the Dudley community between SC Highway 9 and U.S. Highway 601 in a rural area marked by pine woods and fields. On my one trip to the site, I found a typically southern, well-kept family burying ground. The only oddity is the large memorial stone placed there by Captain Blakeney's descendants and the local chapter of the Daughters of the American Revolution (DAR) in the 1950s. I arrived about 8:30 p.m. on a Saturday and saw nothing out of the ordinary. I would advise thrill-seekers or romantically minded teens to look elsewhere and leave this spot to the local historians and genealogists.

JOHNSON ROAD LIGHT: STILL BOUNCING ALONG?

One of the benefits of having written two other books on South Carolina ghost lore and working at a library is getting to hear stories from folks that lead to yet more books. One of those occasions occurred shortly after I took over the Great Falls branch of the Chester County Library. A patron, Charles Steen, told me about an experience he had with what he called a ghost light just after World War II while hunting with his grandfather and great-uncle in rural Chesterfield County. He told me that he had seen a bright white blob of light bouncing down the center of an old roadbed behind what was known as the Old Johnson place near Rocky Creek Presbyterian Church. The light emerged from some brush near Black Creek and followed the road for about twenty-five yards or so before blinking out. Mr. Steen told me that the

object gave off very little light and seemingly no heat, but in the half-light of dusk, it was bright enough to see by from his vantage point about fifty feet away. Mr. Steen said that his grandfather and great-uncle told him that the light was a death omen but would not elaborate. Naturally, I pressed him for detailed directions, but time and distance left his memories too hazy for anything more than a general area. Undaunted, I devoted a large part of the same Saturday night on which I visited the Blakeney family cemetery to trying to locate the light. I did not have any luck, but I feel sure the light is still there, its origin and purpose lost to memory. Good luck and do let me know if you find it.

PROSPECT CHURCH: WHO WOULD FIGHT IN A CHURCH?

Prospect United Methodist Church is an almost stereotypical southern place. The red brick building sits beside its cemetery just off a one-lane blacktop road in a lightly wooded area. However, there are some odd things about it. First, the church has a Hartsville mailing address but is located across the county line in Chesterfield, not Darlington, County. The second strange thing is the reputed haunting. I say "reputed" because some vital pieces of information are easily contradicted. The basic story is fairly straightforward. You drive out to the church, park in the very last parking space on the right side of the church on a night with a full moon and watch the far window on the second floor for the signs of a man engaged in a struggle, such as the curtains moving wildly. One of the online sources I found for this story points out that the church has installed a lamppost near that corner of the building that casts a glare onto the window in question, and the source did confess to not experiencing anything unusual. No records I have consulted mentioned any physical confrontations at the church over its almost

150-year history. But I do love a good story and decided to check it out, in case the previous person just had some bad luck.

Upon arriving at the church, I noticed several issues with the online versions of the haunting at Prospect Church. First, the church is only one story. There is what looks from the outside to be either a fellowship hall or Sunday school rooms in part of the basement and a row of windows behind the stained-glass windows of the sanctuary. The second issue with the current version is that all of the regular windows have blinds, not curtains. The final issue with viewing this reputed haunting is that the view of the last window on the right side of the building is partially blocked by what appears to this layman to be a holly tree. I sat in the parking lot for about twenty minutes gazing at the church and nothing happened. I have to write this story off as the product of overactive teen hormones or boredom. Please don't go out there to try to see anything, as all you'll do is wear out the church's parking lot and probably attract the attention of a passing sheriff's deputy or highway patrolman.

OH BOY, HERE WE GO: THE "REAL" CRYBABY CREEK BRIDGE

Despite all evidence to the contrary, folks persist in claiming that *their* Crybaby Bridge is the *real* one. Look, I'm obviously a huge fan of ghost lore and was a fan of illicit romantic spots in high school and college, but I have my doubts. However, according to an online source, the bridge on U.S. Highway 601 over Flat Creek south of Pageland is the real McCoy. Well, call me a Hatfield then. The back story is instantly familiar. A young mother rushes home from work in a war plant in the 1940s, hoping to beat her husband home. He has finally returned from fighting overseas and she longs to see him again. Unfortunately, she is driving too fast and the car goes off the road and into the creek, throwing the

baby he has never seen from the car. As she frantically searches in the dark water, she hears the child's cries fade. Then, sadly, she dies as well, of a massive heart attack.

Now, if you park on the bridge at night, you will hear the child cry if you call out "Crybaby! Crybaby!" Some witnesses have claimed to have seen a baby's face in the water and to have photographed it. Of course, despite knowing better, I had to try to see if I could entice the baby to scream. So I drove over to the suggested spot and performed the required hollering and waiting, to no avail. I will warn those of you traveling through the area during the summer to be aware of very heavy traffic bound for the beach and to watch out for logging trucks and other truck traffic after dark year-round. Honestly, though, you can probably find a bridge closer to home. Just ask any high school student.

ENFIELD

The haunting at Enfield, the former home of the Burgess and Powe families, dates from a reported incident during the Civil War, when the home served as Union general Oliver O. Howard's headquarters. According to local lore, a slave girl fumbled the reins of a Federal officer's mount and he shot her dead on the porch. Unusual noises, being awakened in the night and noises during phone calls seem to be the hallmarks of this haunting. However, given General Howard's role in the Freedman's Bureau after the war, I doubt that any of his officers would have murdered a slave girl in cold blood and certainly not without paying a severe penalty. Since Enfield is a private home, I could not gain access to the site to verify the haunting. I would think that additional research is needed to firm up the legendary basis for it though.

CLARENDON COUNTY

C larendon County was first established in 1785 and lasted until 1799. The modern county was formed in 1855. Both formations were fashioned out of Sumter County. Clarendon County is bordered by Calhoun, Sumter, Florence, Williamsburg, Berkeley and Orangeburg Counties. The county was named for Edward Hyde, the first Earl of Clarendon and a Lord Proprietor. The Santee Indian Mound serves notice of a native presence from about 1500 BC until the mid-1700s. Clarendon County was the birthplace of the lawsuit *Briggs v. Elliott*, which was later combined with other cases in the *Brown v. Board of Education* case declaring segregation unconstitutional. In fact, *Briggs v. Elliott* was the first such case filed. The county was also the location of the trial of George Stinney Jr., which led to his execution as a fourteen-year-old. He is still the youngest person executed in the United States since 1900. The county seat, Manning, is named for John L. Manning, a local landowner who served as governor of South Carolina from 1852 to 1854. Manning was also a target of Potter's Raid at the end of the Civil War, when the city was partially burned. One of Potter's men, Private Josiah Pratt, is buried there.

Manning is also the birthplace of Peggy Parish, creator of the popular children's literature character Amelia Bedelia. David

Gaillard, engineer of the central part of the Panama Canal, was also born in Clarendon County. Other notable Clarendon County natives include Lieutenant Colonel James A. Walker, an early member of the Tuskegee Airmen and World War II ace, and Marian McKnight, Miss America 1957. Clarendon County has given South Carolina five governors: James B. Richardson, John Manning, John P. Richardson, John P. Richardson II and John P. Richardson III. Clarendon County is also the site of part of Lake Marion, the largest lake in South Carolina. Althea Gibson—the first African American woman to win a Grand Slam tennis title (the 1956 French Open title) and twice winner of singles titles at the U.S. Open and Wimbledon—was born in the Clarendon County community of Silver.

A DEAD MAN'S CURVE NO ONE HAS SUNG ABOUT...YET

Manning, South Carolina, is probably the last place you would expect to find a ghost, but it does have one. According to local legend, the town cemetery is haunted by the father of a victim of a drunk driver. The father appears on the roadside in a curve, sitting in a rocking chair, as he reputedly did in life, waiting for the man who killed his son at that spot to drive past. The printed version of the story claims that the father had recently died and was buried at the curve. Why he waited and what he would have done if he had met the driver are mysteries left unanswered. In any case, the man continued his vigil until his death—and, some say, after it. As all good ghost stories start, on certain nights, when the moon is right, the man reappears in his rocker, waiting. Prom night, Halloween and the night of Manning High School's Homecoming are also supposed to encourage an appearance. He leans forward as you drive past and vanishes after you pass him.

This tale is one of the reasons for the book you are now reading. I *really* wanted to find this curve and drive just a touch erratically to see what would happen if I managed to guess when the moon was right, whatever that means. Of course, I am also the same person who wants to spend his fortieth birthday in a nailed-down sleeping bag across the Devil's Tramping Ground near Siler City, North Carolina, while my trusted friend Bill Roddey films it all with a camcorder, and I have grand plans to spend my fiftieth in the "secret room" at Glamis Castle in Scotland if it's at all possible; your response may vary. One Saturday, I headed off to the Harvin Clarendon County Library in Manning to see if the staff could offer any guidance. As one of my wife's second graders once said, "Library people know *everything*." Sadly, the legend of Dead Man's Curve is apparently either solely an Internet creation or known only to those under eighteen, because neither library worker I spoke to had ever heard of the story, and both were unsure where the town cemetery was located. Finally, one of them decided that the cemetery near the Stephens Funeral Home must be the one I meant. I thanked them and headed over that way.

At the cemetery, I was presented with a quandary. There was a separate circular expansion of the graveyard surrounded by a chain-link fence and a rather rough mud and gravel road. As it was just getting dark and had rained on and off for the last three days, I decided to focus on not getting mired in wet mud over two hours from home and played that drive straight. That excursion passed uneventfully. Once back on pavement, I decided to play a little. I weaved in my lane, being careful not to drift too far into the other lane and watching for oncoming traffic as I drove around the outside of the main, older part of the cemetery.

Sadly, the moon was not right or you must actually need to be drunk to see the man in the rocker, because I had no luck at all, either goofing off or driving normally. Perhaps you will be more successful seeing him. If so, let me know what happens. My money

is on him either dashing in front of you or appearing inside the car. I do strongly urge you *not* to drive drunk, or the next ghost you see may be your own or a loved one's. No ghost is worth what a DUI or DWI would cost. As I have said before, be responsible.

DARLINGTON COUNTY

Darlington County was formed in 1785 as an original county in South Carolina. It is bordered by Lee, Chesterfield, Marlboro and Florence Counties. The county lost territory to both Lee and Florence Counties when they were formed. Two Revolutionary battles were fought in modern Darlington County, both on Black Creek. A fire in the courthouse in March 1806 led to the destruction of most of the colonial records for both the county and much of the colonial Cheraws District, though the grand jury report from November 1774—in which the right of Parliament to tax the colonists was argued—was denied eighteen months prior to the Declaration of Independence. There are several sites in the county associated with the Civil War. These include the site of the attempted ambush of a freight train by Union forces and the burial sites of four privates who died during the early part of Reconstruction. John "Dizzy" Gillespie, the world-renowned jazz musician, was born near Cheraw. Orlando Hudson, Major League All-Star second baseman; Albert Haynesworth, National Football League All-Pro; Bobo Newsom, four-time Major League Baseball All-Star pitcher; and Levon Kirkland, an All-Pro NFL player with the Pittsburgh Steelers, are all well-known figures from the sporting world born in Darlington County. Henry Brown, black veteran of

the Mexican, Civil and Spanish-American Wars, was also a native of Darlington County. The county is also the site of Darlington International Raceway.

The county was named for either a Colonel Darlington from the Revolutionary era or for Darlington, England. Darlington County shares its name with a song title from Bruce Springsteen's 1984 album, *Born in the U.S.A.* South Carolina governors from Darlington County include David Beasley and David Williams, although no U.S. senators have called it home as yet. Leeza Gibbons, television host of shows like *PM Magazine, Entertainment Tonight* and her own talk show *Leeza*, was born in Hartsville.

LAMAR HIGH SCHOOL: A REMEMBRANCE LEADS TO A GHOST?

The town of Lamar is located in the southwestern corner of Darlington County. It is the hometown of two former standout defensive players for Clemson University, Bill Hudson and Levon Kirkland. Hudson, a defensive lineman, played in the American Football League in the early 1960s for the Chargers and the Patriots. Kirkland, a two-time All-Pro linebacker for the Steelers, Seahawks and Eagles, played in the 1990s. Lamar High School has a student body of about three hundred and is known for both academic and athletic prowess. It is also known for a tragic ghost story. According to online sources, a Lamar High School girls' basketball player was killed in a car wreck. Afterward, her jersey and locker were retired. On the anniversary of her death, she supposedly returns to the site of her greatest glory and plays a game.

Obviously, not being an alumnus of Lamar High, I cannot testify to the veracity of this tale nor could I gain access to the gym after hours. So I contacted the school and requested an honest answer to the question of the girl's annual return. I was informed

that no one at the school had heard of the story before but that the root of the tale was true. A student named Courtney Bell did play basketball and did die in a traffic accident during her senior year. Her picture and shoes are located in the school's trophy case, and her number has been retired. The school also established a scholarship fund in her name. So while I can't claim for certain that the story is untrue, I have encountered enough bogus claims of ghosts in schools meant to terrorize underclassmen that I will include this story on that list. Thankfully, with the scholarship, this story has a somewhat happier ending.

DID GHOSTS MAKE THE FORMER LINCOLN VILLAGE APARTMENTS CLOSE?

The former Lincoln Village apartment complex in Hartsville closed in the late 1970s or early 1980s. No one I have spoken to remembers why, though most people blamed the poor economy of the time. However, according to several online accounts, some unmarked graves disturbed by the construction may have led to the complex's closing. Lincoln Village was located near the Greenlawn Cemetery, and some of the buildings may have been built over unmarked or poorly marked graves. This led to residents complaining of babies crying and adult voices begging for help in otherwise empty apartments. Some people even claimed to have seen figures walking around outside and into buildings.

The complex was set up around a central parking lot with six buildings on three sides. On the next side street, two smaller buildings and two similar to the other six face the street. In the rear corner, between buildings C and D, some woods angle toward the apartments. In those woods, I located the grave of an infant named Moseley and several unmarked and sunken graves. This does tend to lend credence to the stories. An anonymous sheriff's deputy I

talked to mentioned that most of the calls in the neighborhood were in response to drug crimes and assaults but that he had been called out to investigate lights on in the vacant buildings and people appearing in windows. He strongly discouraged trespassing at the site due to the rough nature of the neighborhood and potential dangers in the empty buildings. While I was at the site, I was struck by a profound sense of sorrow but did not hear or see anything unusual. If you decide to visit the site, I would advise checking in with the local police, for safety reasons and to be responsible researchers. Otherwise, as I have said before, you are on your own and if you break the law, blame yourself.

MADELINE: ANOTHER IN A LONG LINE OF SPECTRAL STUDENTS

Coker College began in 1894 as Welsh Neck High, founded by a local businessman and Civil War veteran, Major James L. Coker, also the founder of the Carolina Fiber Company, the forerunner of Sonoco. In 1908, when South Carolina finally created a statewide public school system, Major Coker provided leadership for the conversion of the school to Coker College for Women. From the 1920s until just after World War II, it was the only college between Columbia and Charleston accredited by the Southern Association of Colleges and Schools. A liberal arts college, it was once affiliated with the South Carolina Baptist Convention but has been nondenominational since 1944. It officially became coed in 1969, although men have been attending since World War II. From 1988 to 2003, Coker students often interacted with students from the South Carolina Governor's School for Science and Mathematics, who lived and took their own courses on campus. In 2003, the Governor's School moved to its own dedicated campus a few blocks away. Hartsville and Coker College owe much to the generosity of

the Coker family, founders of Sonoco and Coker's Pedigreed Seed Company. The Coker family's patronage of the college has led to the vast majority of buildings on campus having Coker somewhere in the name. Students often joke to freshmen or visitors that they'll meet them "in the Coker" building as a way to gently initiate newcomers to campus.

Memorial Hall is the oldest residence hall on campus, having been built in 1914, and is the site of the reputed haunting. According to campus legend, the haunting dates back to the early 1920s, when a student named Madeline Savage was involved with a professor. She became pregnant, the man refused responsibility and the girl's shame led her to suicide by hanging herself in either the elevator shaft or the attic in Memorial Hall, where she lived. The fact that the real Madeline Savage simply transferred from Coker to another school and lived on until 1978 has not made any impact on the stories or on the spirit's supposed identity.

Since her "death" or disappearance from campus records, Madeline has appeared all over campus but especially in Memorial Hall and the former and current library buildings. When she has been seen, she is described as a tall, thin girl with long brown hair, and she is dressed in a white gown. Some humorous accounts of her exploits give her some unusual accessories: a frayed rope around her neck and seaweed in her hair. She is best known for pulling harmless pranks like causing exit signs to flash without bulbs in them, shutters opening and closing, crying from empty rooms, alarm clocks going off at odd hours when correctly set and radios that power on and off without human help. People working late have reported feeling icy fingers on their necks in empty rooms and halls. There are also reports of her apparition being seen both in the stairwell that now occupies the elevator shaft and the attic of Memorial Hall.

Following renovations to the former library building in the late 1990s, she became especially active there, as if attracted by

the hustle and bustle. With the new library open and the former building in the process of being converted to campus housing, I will be curious to see if Madeline pays the new residence a visit. Sadly, during my one brief visit to Coker, I did not see Madeline. I assume that since I was not a faculty member or student, she decided that I was unworthy of notice. Hopefully, I will have better luck on my next visit.

"MEXICAN SLAUGHTER HOUSE": DID SOMEBODY WATCH ONE MOVIE TOO MANY?

Near the campus of Coker College, a rather odd haunted site used to be the target of much speculation but no verification. In fact, no one knows which house deserved the title, and an unnamed veteran Hartsville police officer had never even heard of the story, despite his more than twenty years of experience. The online account is frustratingly brief and cryptic. It describes an old white house that has been torn down at some point but never clarifies if the haunting is tied to the house or the lot. It is claimed that there is no electricity at the site, though, again, the timeline is hazy at best. According to one source, the house was located near the Coker campus in town, but another source advises you to drive way out there late at night. Either way, you'll see a light and hear voices talking. Then, you'll hear screams and see people running out of the house. Again, the timeline is muddled. I include this story only because of its prevalence online. I honestly think this was the work of a bored mind more than anything else.

A MONTROSE CEMETERY BY ANY OTHER NAME

One amusing thing about doing research for a book like this is the variety of places I get to visit. At times, the novelty is focused on what a place is literally known as. With that said, here we go. I'll cover the versions for the names under which they appear in the various sources, and then I will summarize what happened on my visit. The "Montrose Graveyard" or Montross Cemetery (with and without the "Old") centers on what was originally the Montrose Church cemetery prior to its destruction by fire in the 1800s and replacement on the site by Mount Hope Church. Due to years of neglect, a collective marker was placed at the site to note the missing and damaged stones. Supposedly, the 1960s saw a large black man murder several children at the graveyard, and he may or may not have been the father. This has led to reports of children screaming and crying in terror, followed by silence and the appearance of a large black shape with a set of red eyes boring into the eyes of witnesses. Feelings of dread and nausea have also been reported, both alone and in conjunction with other events. A large cold spot has been mentioned in some reports at the entrance, with some claiming temperatures up to fifteen degrees colder at that spot, though most claim that the difference is ten degrees at most.

Under the name of "Old Montorse [*sic*]," the date of the fire was given as the early 1900s according to the online account, and mention was made of the appearance of a young boy in an antebellum gray suit, standing behind a damaged stone reading "Joseph" or "Joseph Wallace." One account gave his birth date as 1822. The sound of childish laughter was heard at the same time. When approached, the boy vanished and silence returned.

Under the heading of Lowther's Hill Cemetery, yet another ghost is added to the mix. Supposedly, a major local landowner had a slave named Montrose who was to supervise his master's daughter and her pony. Sadly, the child was not a skilled rider and the pony

ran away with her, to disastrous results. The master, in a fury, cursed his servant to eternally stand guard over the daughter's grave, and he was also buried next to her. Now he confronts strangers who visit the site. I will add that the source of this story claims that the grave has the stink of the lamp to it. However, another odd event features a creature that has been extinct for almost one hundred years. According to a secondhand account, a Carolina parakeet flew through the open windows of the source's parent's car just before World War II. This catches one's eye because the last known Carolina parakeet died at the Cincinnati Zoo in 1918.

So how do we separate out the facts from the fiction, if possible? We researched the site, of course. No murders have been known to have occurred at the cemetery, and no unburied bodies have been found there. So I think we can safely relegate the murderous father or child killer to local lore meant to entice your girlfriend to leap into your arms for protection…or whatever else. The slave cursed to stand eternal watch over a young charge sounds like the imagination of someone who has read too much Simms or Timrod, so I feel pretty safe in discarding that tale. The balance of the events, with the exception of the parakeet in the car, tends to fit in well with my experiences at both the Old Montrose Graveyard and at other cemeteries at which I've encountered ghosts. I will say now that I've never felt any cold spot register much more than a five- or six-degree difference on any thermometer, digital or mercury; otherwise, I could even accept the extreme cold spot at the entrance.

On my visit several years ago, I was disheartened by the sheer amount of trash—mainly beer cans, liquor bottles and other, more exotic items—littering the site and the thickness of the underbrush. As a local historian with a deep interest in cemetery preservation, the condition of the stones angered me even more. Despite this less than receptive mood, I was immediately struck with a sense of dread and deep depression, which was strange to someone

normally as prone to such things as a wooden post. I also felt like I had entered a room full of people at an inopportune moment and conversation had ceased until I left. I saw nothing and heard no screams from murdered children or weeping, but I left after about fifteen minutes and would not return after dark for any amount of folding money. While doing research for this book, I have learned that a local group began not only to clean up the graveyard but also to hold sunrise services on Easter and begin to restore some of the stones. I commend their efforts, wish them the best of luck and would be happy to offer any help I can...in the daytime.

OLD MAN JOE: A CRYBABY BRIDGE WITHOUT THE BRIDGE

One curious thing about the haunted sites collected here is the lack of Crybaby Bridges. I had no doubt that I would find at least two or three, if for no other reason than the years that Donald "Pee Wee" Gaskins was actively committing several murders in the region. So it came as a surprise when the time came to type up my notes into a manuscript and I discovered that I had few for such bridges. Well, at least I thought so, until I recalled the story of "Old Man Joe." All it lacks is the bridge. Somewhere near Hartsville, an older man was riding down a dirt road in or on some vehicle—the source I found is lacking in such minor details. He attempted to light his pipe but dropped his lighter. When he bent down to retrieve it, he ran off the road into an unnamed creek and was killed instantly. The ritual to summon this revenant is quite convoluted. You must roll the windows up in the car; everyone must get out of the car, lock all the doors and place the keys on the hood. You then strike a lighter three times and either one person or all need to say, "Old Man Joe I got a light for your pipe!" After the third time you repeat the chant, you will hear him running through the water toward you.

Good Lord. Getting a marriage license is less work for a better payoff. I can imagine, as a reluctant ex-smoker, that the craving for nicotine could well survive even death, but mercy. I'm sure that in the days before power locks this would have been much more thrilling too. Basically, you get out of the car, chattering steadily and mocking the last one out. Then, after you've rolled windows up, locked doors and placed keys, your ears adjust to the lack of background noise just in time for the shouted chant. As it dies, your hearing, still sensitive from before, picks up the water of the creek running through either the bridge or, more likely in this case, through the culvert and your mind makes a logical guess that someone is coming. You get the thrill of necromancy without the mess of grave robbing. I advise any fan of "Crybaby Bridge" or "Old Man Joe" to go with someone you trust and to drive your own car, as the temptation to pull just a few yards away under the threat of leaving the other person can be quite powerful.

CHAPTER 5

DILLON COUNTY

D illon County was formed in 1910 from part of Marion County. It borders North Carolina and the counties of Marlboro, Marion and Florence. It was named after J.W. Dillon, who led the fight to both form the new county and have access to a railroad. There are no native or Civil War sites associated with the county, though the area was once part of the Lumbee tribe's territory prior to white settlement. Two Revolutionary battles were fought solely in Dillon County, and another occurred on the border with Marion County. It is the site of South of the Border, which we will investigate more in depth in a moment. Ben Bernanke, the chairman of the Federal Reserve as of 2009, is a graduate of Dillon High School. Latta is the birthplace of Chuck Jackson, a noted soul singer; Carlisle Floyd, an American opera composer focusing on southern themes; and Raymond Felton, a player for the National Basketball Association's Charlotte Bobcats and former star for the University of North Carolina (UNC) Tar Heels basketball team.

AVALON ACADEMY

Avalon Academy was a small private school in Dillon. Enrollment was roughly one hundred, with no more than a dozen seniors enrolled any year prior to its closure in 2007. By all accounts, it was not the place you would expect to find a haunting, much less an apparent curse. If the online source I found has any validity (which I doubt), Avalon Academy had both. No explanation is given for the apparent curse, but supposedly, every year at least one male senior would either be seriously hurt or die. No proof or even an example is offered for this bizarre statement, but we'll take it at face value for now and move on to the reputed haunting. According to the seemingly eyewitness account, if there is a ring present around the full moon (which I was always told meant snow), passersby will hear screams and the sounds of doors and lockers slamming. Translucent figures have been seen walking the halls and opening lockers. Again, if you credit the online source, these events have been witnessed by sports teams returning from road games. Since the post has been removed and the school is now defunct, I wonder if the events continue. This tale sadly lacks any form of credence. I have ridden past the school under "optimal" conditions en route to the beach twice and have seen and heard nothing unusual, even before the school closed. Of course, if you are interested in setting a private school in Dillon...

BINGHAM'S LIGHT: THIS LITTLE LIGHT OF MINE

No supernatural or unexplained phenomenon produces more varied back stories than a spook light, corpse light, earthlight or even will-o'-the-wisp, to use just a few of the terms for this most common ghost legend. The stories all have striking similarities despite wide geographical distribution, much like Crybaby

Bridges. However, ghost lights are fairly consistent in their appearances and require no great psychic ability to be seen. I think the comparable lack of more contemporary spook light stories is the shift to attribute any odd light in the sky or on the horizon to a UFO rather than a spirit.

Most single spook lights—like Bingham's Light, the Maco Light of North Carolina (seen by ex-president Grover Cleveland of all people), the Hornet Spooklight of the Missouri/Oklahoma border and the Summerville Light, which we will encounter in Dorchester County shortly—all share a connection to railroad tracks that were present at some point, even if they have been removed since. Most of the stories date the reason for the light, usually a derailment or decapitation, to the late nineteenth or early twentieth centuries, though in some cases the light may not enter the public imagination until decades later. One final thing about spook lights in general and Bingham's Light in particular is that they make good television. Even the spook light groupings like the Marfa Lights in Texas and the Brown Mountain Lights in North Carolina have been featured on several different shows. Bingham's Light has been featured on *PM Magazine*, *20/20* and *Unsolved Mysteries*, to name a few.

The best way to tell the stories behind Bingham's Light is to tell the versions from the different sources and then describe my own experiences. The first and most commonly dispersed version concerns two children who were lost in a blizzard in the early 1800s. Their father set off into the storm at night with a lantern and a rifle, and he vanished as well. Now, if you drive to the area near Reedy Creek Springs to a hill between two cemeteries you will see his lantern. If you call out that you have his children, the light glows a fiery red. In this version, no names are given and the directions to the site are sketchy at best, though the original source does mention that the access road is now gated and blames people who have shot at the light for this.

The second version matches more closely with other spook light legends. On the railroad tracks near the old and now defunct Reedy Creek Springs resort, a worker was beheaded by a passing train while repairing some fault in the tracks at night. To summon the light, you must shout, "Bill Bingham, come out!" which smacks of the rituals tied to all those Crybaby Bridges we know and love from our teenage days. The light will appear and sway back and forth in a tight arc, like a lantern held at arm's length. One oddity about this version is the mention of an instance when a witness swore at the light and it moved to that person's car and drained the battery. According to this version, the light glowed but put out no heat and would change direction without warning. I believe this version has been cross-pollinated with some UFO lore as well.

The third version is similar to the second, but the worker's name is given as John Bingham and no mention is made of having to call the light. The worker seeks his missing head, which was not recovered (it never is), fearful that he will not be able to go to heaven unless he is whole—hence his return. In this version, when a witness shot at the light with a shotgun, it split into two separate lights and changed colors. There are also reports of mechanical failures with vehicles and a feeling of nausea when the light passed close by. The apparent intelligence displayed by the light in the previous version is lacking, making this version truer to the standard version.

The fourth version claims that the trains' victim was a passing hunter who saw an unknown blockage on the tracks and attempted to both remove it and warn the oncoming train with his kerosene lantern. Sadly, the lantern was low on fuel, which would help explain the flickering and color changes that the light has been known to show. If the lantern was never found, how the storyteller knew that it was low on fuel goes unexplained.

The final version of the back story in circulation concerns a local farmer who became too enamored of moonshine and, in a drunken haze, may or may not have killed his wife and family and

then placed his head on the railroad tracks in remorse. A passing freight ended his life. Legend has it that the light is either the fire from his still (doubtful since most stills are stationary) or from his lantern lighting his way as he seeks forgiveness for his act.

My personal encounter was rather mundane. I drove to the area using directions found online and parked at the locked gate. After my eyes adjusted to the near total darkness, I began scanning the ridgeline and horizon. After about five minutes, I noticed a faint and compact orange glow seemingly rolling at a snail's pace along the ridgeline. Having checked current maps, I knew that there was no road or railroad tracks in the area, and I know of few loggers who work after 10:00 p.m. After about a minute, the light vanished abruptly. It made no mad dash toward me and my car started normally. Of course, I'm not foolish enough to fire a rifle or shotgun into dark woods with nothing in season, and I saw no reason to swear since it was mid-fall and the bugs were at a minimum. I headed home thrilled to have seen the light and hoped to entice some friends to tag along. I have one friend who was alone in not seeing the Brown Mountain Lights out of a crowd of about eight people. I hope he has better luck with Bingham's Light. Of course, since the Bingham community is on the route of the proposed I-73, with an exit planned for the area known for the most sightings, we may need to hurry back.

SOUTH OF THE BORDER: ALL TOURISTS WELCOME...LIVING OR DEAD

South of the Border is a roadside attraction at the intersections of I-95 and U.S. Highway 301/501 near Hamer, South Carolina, so named because it is just "south of the border" between North and South Carolina. The rest area features not only restaurants, gas stations and motels but also a small amusement park, shopping

and fireworks. Its mascot is Pedro, an extravagantly stereotypical Mexican. It is advertised by hundreds of billboards along I-95 that start 175 miles away. Well-known landmarks in the area, the irreverent signs feature Pedro counting down the number of miles to South of the Border, usually with some pithy or witty comment, occasionally in dialect.

South of the Border was developed by Al Schafer, who founded a beer stand at the location in 1950 to avoid the dry status of Robeson County, North Carolina, at the time and steadily expanded it with Mexican trinkets and numerous kitschy items. South of the Border grew to over a square mile in size, eventually required its own infrastructure and had its own fire and police departments. South of the Border, for me, harkens back to what it must have been like driving Route 66 in its glory, with the Pedro signs serving as modern and occasionally offensive Burma-Shave signs. It is a quintessentially American experience, and like all good roadside attractions, there's more than meets the eye. Yes, Virginia, South of the Border is supposed to have its very own ghost.

According to hearsay and online accounts, room 305 at the South of the Border Motor Inn, also known as Pedro's Pleasure Dome, is haunted by the spirits of those disturbed when the building was built over an abandoned cemetery. Now, I know small southern towns aren't hotbeds of regulation, but we are fond of our history. I highly doubt that any developer would build over a marked grave, much less a whole cemetery. I will concede that a long-forgotten and completely unmarked Native American or slave graveyard may have been built over, but no recognizably human remains were disturbed. Another theory to explain the reported haunting is that two different guests have died in the room since the inn opened in the mid-1980s. The reports are not clear if the two dead guests were killed by the ghosts or have simply joined them. Sadly, there are no records of any deaths in any of the rooms, not even room 305.

Allow me a brief rant here for a moment, since this is my book. I enjoy a good scary movie, but come on Hollywood! I've been interested in ghosts for over twenty-five years at this writing and have seen way too many in person, and I have never been harmed in any way by a ghost. I have been scared enough to do stupid things that could have led to injury, but I've never been possessed or attacked at all. So please, next time spare us the gore and just tell the stories. The stories are why we buy the books and go track these things down, not the chance that we'll be attacked by spectral hammers or forced to jump off a cliff. So, no, I don't think the dead guests (which aren't real) were killed by vengeful spirits.

In any case, the haunting features odd power outages, doors that refuse to unlock for guests, pets that either refuse to enter the room or spend hours in pursuit of invisible prey and apparitions. In fact, the story of the haunted room only dates to the turn of the current century. I have never spent the night at South of the Border, but now I feel the urge, despite the fact that I can go there and back in less than a day, just in case.

DORCHESTER COUNTY

D orchester County was named for Dorchester, Massachusetts, the home of several early settlers. The county was formed in 1897 from Berkeley and Colleton Counties, though settlement under several parish names occurred about 1700. From 1786 until 1882, Dorchester County was part of Charleston County. The county is bordered by Colleton, Orangeburg, Berkeley and Charleston Counties. Five Revolutionary War battles took place in the county, three for possession of Old Dorchester, now a state park. Old Dorchester was a thriving town from 1697 until 1788, when it was abandoned. No U.S. senators have hailed from Dorchester County as yet. One fort during the Westo War of 1680 and three from the Yamasee War record the conflicts with the natives that occurred until about 1750. No battles occurred in the present county, despite its proximity to Charleston during these wars. The Middleton family has been active in the affairs of county, state and nation from the 1740s. The first Henry Middleton served as the second president of the Continental Congress from 1774 until 1775. His son, Arthur Middleton, signed the Declaration of Independence. The second Arthur Middleton served his state as governor and his nation as minister to Russia throughout the 1820s. The family introduced the camellia, Asiatic azalea and crape myrtle to America. The Civil

War affected the county mainly through the looting and burning of several plantations, including Middleton Place.

ARCHDALE HALL

Archdale Hall was the seat of the Baker and Bohun Baker families from 1681 until the death of the last direct descendant in 1901. In 1782, two retreating British soldiers broke into Archdale Hall and stole the family silver from its hiding place. The fourth Richard Bohun Baker was the last surviving officer from the Revolutionary battle at Fort Moultrie at his death in 1837. Until the end of the Civil War, the Baker and Bohun Baker families were prominent both socially and politically. The décor of Archdale before its destruction included portraits of Richard Bohun Baker III and Elizabeth Elliott by Jeremiah Theus, a Swiss artist and painter of many members of the Lowcountry's pre-Revolutionary aristocracy. Archdale Hall was also unusual in that it had a hospital for slaves on site.

The actual haunting of Archdale Hall was by all accounts a crisis apparition. A crisis apparition is usually a one-time event tied to trauma, usually the death of a loved one, though danger to one's person or surroundings can trigger one as well. A better example of this concept would be the vision of a soldier on active duty overseas appearing to a relative at home at an odd hour with no warning—later, the relative learns that the time of the visitation coincided with the loved one's death. The crisis that triggered the haunting at Archdale was the Great Charleston Earthquake of 1886. The 1886 earthquake struck about 10:00 p.m. and lasted less than a minute. It measured an estimated 7.0 on the Richter scale. There was almost no warning of the coming earthquake as there had been no recorded seismic activity in South Carolina beforehand. The Charleston Earthquake of 1886 is the largest to ever strike the East Coast of the United States.

Dr. Richard Bohun Baker VI was alone and ill in bed at Archdale on that fateful night in August. Late in the night, the entire south wall and three corners of the structure collapsed. Dr. Baker escaped to the lawn, where he watched the tremors hammer his ancestral home. There was a strong odor of sulfur in the air and an oppressive, breathless heat. Richard, sitting there alone in the dim light of a mist-shrouded moon, heard strange sounds and saw the shadows of those long departed rise from the family plot to bear witness to the old house's destruction. Before repairs could be made, the roof caved in due to rain and the house was abandoned and became a ruin. These ruins of the plantation house can still be seen today and are maintained by the Archdale Civil Association. No other accounts of any other haunting have been reported since. On my visit to the site, I found a well-kept subdivision and the ruins of the once proud home but had no unusual experiences at all.

JEDBURG RAIL TRESTLE

The town of Jedburg is a small bedroom community north of the cities of Charleston, North Charleston and Summerville. It is a typical small southern town. Life moves at a slower pace and no crisis seems to last. Like many other small southern towns, it boasts of two ghosts on one railroad trestle. According to an account I found online, the trestle is haunted by two men. One is a glowing white figure who will move in unison with the observer—if you approach him, he moves closer and vice versa. The second figure is a man with a scarred face, wearing bright-colored clothing and carrying a newly sharpened hand axe or hatchet. The source, which claims to be an eyewitness account, states that the two figures are connected to each other and to a murder that occurred in the 1950s at the old depot in Jedburg. Supposedly, two cousins were involved in a

dispute over a hat, and the one wearing the hat was fatally struck in the face with a stick or an axe by the other man. The assailant dragged the body to the nearby trestle and tossed it over the side. The murderer was sentenced to a lengthy term in prison.

Seeing that I am a sucker for both trains and ghosts, I had to investigate this story further. I was not overly upset when no mention of the murder turned up in any newspaper searches, as the timeline I had was sketchy and could have easily been off. I located the tracks just off U.S. Highway 78 and walked to the trestle, keeping my eye out for any snakes warming themselves and an ear out for any oncoming trains. After crossing and recrossing the trestle several times and seeing nothing but my shadow in the ninety-degree heat, I gave up and headed off to find some water and air conditioning. Hey, being a native southerner doesn't mean I enjoy our summers any more than a tourist.

PARKS CEMETERY

Parks Cemetery was established in 1941 by the Parks family as an offshoot of their funeral home business and is also known as Summerville Cemetery and Mausoleum. As per a roster compiled in 1979, over one thousand interments have occurred there. I feel reasonably safe in asserting that that number may well have doubled since. I have only located one mention of a haunting at the Parks Cemetery, and I could not verify any of the details. According to the account posted online, a child's grave marked only by a mortuary marker at the rear of the cemetery was the focal point of the sound of a child crying and the smell of wood smoke. If items were placed on the grave, the sensations stopped. I could not locate the grave on my visit and have not mentioned the child's name to protect both her privacy and that of her family. I will mention that she is not listed on the cemetery roster as recently as 2006.

PRICE HOUSE COTTAGE

The Price House Cottage bed-and-breakfast is located in a small cottage behind the main house on the property in Summerville, South Carolina. The main house is on the National Register of Historic Places, as it is the second-oldest house in Summerville and was built in 1812. The Price House Cottage is located in Summerville's historic district. The haunting is focused in the main house, which guests can normally access only for gourmet breakfasts on the weekends or for drinks if the Prices extend an invitation. The ghost has not yet made an appearance in the flesh, so to speak, but has made her presence known. Faucets have been turned on in empty bathrooms, clocks have stopped despite normally keeping perfect time and footsteps have been heard. The primary manifestation, and the reason the ghost is known as a she, has been the fact that jewelry has gone missing only to reappear in odd places. The more unusual the piece, the greater the likelihood there is of it disappearing. I have not yet met the ghost at the Price House Cottage, despite my best efforts at attempting to persuade my wife to have us spend our anniversary there. Sadly, she has learned over the years that if I want to stay overnight at a specific hotel, there's probably a ghost. Otherwise, a hotel room is a place to sleep and keep my stuff while I see the sights. I am still hopeful, however, that I can convince her.

SUMMERVILLE LIGHT

The Summerville Light, like so many spook lights, is connected with a now vanished railroad bed. The oddity about this particular light is that, though the story does involve a beheaded railway worker, the light is connected to his angry and possibly deranged wife. The back story features the now familiar railway worker

killed and decapitated by a train derailment during his midnight shift, while his wife waits trackside to deliver his lunch. He was buried (with his head, if the stories are to be believed), and his wife refused to accept his death and stalked the tracks with a lantern, looking for him or someone to blame—the accounts are hazy on that point. Regardless, she still walks with the lantern and is not at all pleased to see anyone gawking at her sorrow. The light has been attributed to glare from passing traffic on I-26, despite having been seen prior to the road's construction and despite the distance from the interstate.

The light has been blamed for all manner of damages such as dented car bumpers, scorch marks on car hoods and several other mechanical mishaps, not the least of which is complete failure of several cars' electrical system. Digital cameras, iPods and flashlights have all been known to go haywire as well. Two final odd pranks for which the light has been known include heating up metal buttons and zippers on clothing, as well as passing through parked cars, while causing temperature drops that have led to frost inside on summer nights. Somehow, I'm willing to bet my pocket change (hey, I'm a county employee) that a teenage couple caught *in flagrante delicto* came up with the idea of the superhot buttons and zippers. Several colors have been reported—red, white, yellow, orange and even green.

On my trip to see the light, I managed to find the turn with little trouble and bounced along the dirt logging road to a likely spot. The area is typical of any area that has been logged within a few years: open of large trees but covered with scrub and underbrush. After about ten minutes of waiting, a yellow orb appeared just above the tree line and passed by over my entire field of vision. No attack followed and my car was unscathed, save from the jostling, mud and scratches from the occasional branch on the way in and out. All in all, a routine ghost hunt and one well worth retaking.

FLORENCE COUNTY

Florence County was founded in 1888 from parts of Marion, Darlington, Williamsburg and Clarendon Counties. The county was named for Florence Harllee, the daughter of General W.W. Harllee, the president of the Wilmington and Manchester Railroad when the city and county were founded. Florence County is bordered by Darlington, Marlboro, Dillon, Marion, Williamsburg, Lee, Clarendon and Sumter Counties. The county is home to Francis Marion University. Though no governors or U.S. senators have called Florence County home, the county is well known for the sports stars that it has produced. These include NFL stars like Harry Carson, Hall of Famer for the New York Giants; two-time All-Pro John Abraham; and former MLB vagabond and All-Star Reggie Sanders. However, it is for NASCAR that the region is best known, and Florence County is home to Cale Yarborough, the first man to win three straight Winston Cup titles (1976–78), and Buddy Baker, 1980 Daytona 500 Champion.

Other notables from the county include Melvin Purvis, the Federal Bureau of Investigation (FBI) agent who led manhunts against John Dillinger, "Machine Gun" Kelly and "Pretty Boy" Floyd in the 1930s, and Ronald McNair, a NASA astronaut who died in the 1986 *Challenger* space shuttle explosion. A less savory

notable was Donald "Pee Wee" Gaskins, who was a serial pedophile, rapist and multiple murderer.

Florence County was the site of four Revolutionary War actions. The county's tie to the Civil War is the Florence Stockade, near the Florence National Cemetery, where 2,800 of the prisoners are buried. Florence County is also the location of the eastern terminus of I-20 and is located almost halfway between New York and Miami on I-95. Mars Bluff is famed for having had an unarmed atomic bomb accidentally dropped on it due to a B-47's navigator error on March 11, 1958. The site is accessible off U.S. Highway 501, en route to Myrtle Beach. A few minor injuries were reported, but a house was destroyed.

DEWEY CARTER ELEMENTARY SCHOOL: BORED TEACHERS LEAD TO FOOTSTEPS IN THE CEILING

According to an Internet source, Dewey Carter Elementary School is haunted. Staff members have supposedly heard people in the ceiling. I do not know if that means people walking in the drop ceiling or people talking in the ceiling or both. The supposed eyewitness also claims that you can see fire on the playground at midnight. I have no idea if this means that some of the equipment looks to be on fire or what exactly. I also assume that the fire shows up every midnight. Naturally, I took this as a personal challenge. So the last time my wife and I spent a week at North Myrtle Beach, I drove the hour or so back one night so I could attempt to verify the fiery playground at least. Sadly, the only light I saw was the glare from a streetlight. A recent call to the school resulted in an emphatic and unqualified denial of any haunting at all, especially something as silly as people in a ceiling.

FLORENA BUDWIN AND THE FLORENCE NATIONAL CEMETERY

Florena Budwin holds a unique dual claim to fame. She was not only the first female to be buried in a national cemetery, but she was also the first to earn the distinction through her own military service. Hailing from Philadelphia, she enlisted to be near her husband, disguised herself in uniform and took full part in the fighting. This was possible only due to the lack of physical examinations for recruits at the time. The unit in which she served is lost to history, as is the identity of her husband. What is known is that she was captured with her husband and sent to the infamous prison camp at Andersonville, Georgia. When that prisoner of war camp closed due to the approach of Sherman's armies en route to Savannah and the sea, the prisoners there were moved to Florence. Prior to the move, Mr. Budwin was killed at Andersonville, though the sources are unclear on the guilty party.

After arriving in Florence, Florena's deception was discovered during a routine physical. The ladies of 1864 Florence were astounded and very much put out by the prospect of a widowed female living in the midst of thousands of men *and* wearing men's clothing at the same time. So they hastily arranged a private room and provided her with suitable clothes. She served as a nurse until her death during an undetermined epidemic in January 1865, a mere month before she would have been released.

Florena Budwin is buried in grave number D-2480, which stands alone even now from her male comrades in arms. Both recent investigations and my own experiences lead me to think that Mrs. Budwin sadly may not rest in peace and that she may not be alone in that respect. I have observed a small ball of greenish-yellow light hovering over her tombstone. Among the trench graves where most of her colleagues lie, both myself and other investigators have heard gasps and moans on separate occasions. A moving

cold spot has been detected, even in the late fall and early winter. Electromagnetic field (EMF) spikes have also been recorded, which some more scientifically minded ghost researchers think are a sign of the presence of spirits. I am leery of this method of detection, having seen people use these meters without any rudimentary training or any attempts at gaining a base reading.

SANSBURY HILL GRAVEYARD: WHO WEEPS AND WHY?

Sansbury Hill Graveyard near Timmonsville and I-95 is odd in that after the Civil War it changed hands from a predominantly white group of families to a mainly African American one. As a private burying ground, this is the first time I have heard of such a transfer without an exodus of members of a church of one race or the other. Most private graveyards like Sansbury Hill remain consistent over the years, at least per my experience as both a local historian and a ghost nut. However, I doubt that this racial shift has anything to do with any possible hauntings at the site. Several visitors have reported hearing a baby crying and other undefined sounds, as well as feeling a sense of deep despair and sheer terror. On my one, rather hurried, visit to the site on a cold, rainy December Saturday, the only sound I heard was the steady drumbeat of raindrops on dry leaves and blacktop while the wind cut through my lightweight sweater. I wish you both better luck and better weather on your visit.

KERSHAW COUNTY

K ershaw County was founded in 1791 from parts of Lancaster, Fairfield, Richland and the now ghost county of Claremont. It is bordered by Lancaster, Chesterfield, Lee, Sumter, Richland and Fairfield Counties. The county was named for Joseph Kershaw, an early settler. During the Revolution, the British occupied Camden from June 1780 to May 1781. Fourteen actions took place in the area, including the Battle of Camden on August 16, 1780, and the Battle of Hobkirk's Hill on April 25, 1781, which was witnessed by a young Andrew Jackson while he was a prisoner of war.

Kershaw County has a rich military history, producing several notable soldiers. Confederate soldier and hero at the Battle of Fredericksburg, Richard Kirkland—known to history as the Angel of Marye's Heights for giving water to the wounded on both sides—was also from Kershaw County and served under General Kershaw. Troops under Union general William Sherman burned parts of Camden in February 1865. During World War I, two Kershaw County men were awarded the Medal of Honor in two separate actions while fighting in France in October 1918. The first was Richmond Hobson Hilton, awarded his medal for actions taking place on October 11, 1918, during which he lost an arm. The second was John Canty Villepigue on October 15, 1918,

in an action that resulted in his death months later from injuries received. Villepigue was a descendant of General John Bordenave Villepigue. Donald Truesdale won the medal while serving in the Marine Corps in Nicaragua in 1932.

Statesman, presidential adviser and financier Bernard M. Baruch and American Federation of Labor and Congress of Industrial Organizations (AFL-CIO) president Lane Kirkland were born in Kershaw County, as was the first African American baseball player in the American League and Hall of Famer Larry Doby, who played for the Cleveland Indians and Chicago White Sox. Doby was also the second African American manager of an MLB team when he was hired in 1978 to manage the White Sox. NFL players from Kershaw County include Vonnie Holliday and Bobby Engram. Former South Carolina governors John C. West (who also served as President Carter's ambassador to Saudi Arabia) and James G. Richards were also from Kershaw County, as was U.S. senator James Chestnut Jr. Camden is the site of the major steeplechase races, the Carolina Cup and Colonial Cup. Noted R&B singer/songwriter Brook Benton, best known for "Rainy Night in Georgia," was also born in the county.

AGNES OF GLASGOW: DOES SHE STILL SEEK HER LOVE?

One of Camden's better-known ghost legends centers on a young lady known as Agnes of Glasgow. According to the romantic legend, she so loved Lieutenant Angus McPherson that she left home and hearth and followed him to South Carolina when he was sent here under General Cornwallis. In fact, some sources say that she had abandoned the lieutenant for the general by the time of departure and was with Cornwallis until just before he left Camden. Of course, some scholars, far less chivalrous than I, have

even accused her of being a mere camp follower and kept woman. Sadly, according to the most common version, she had to take a later boat and was separated from McPherson in Charleston. But love will find a way, and she soon learned his regiment's destination in the backcountry.

Sadly, Agnes had been stricken with yellow fever and never saw her love again. In fact, if not for the friendly chief of the Catawba tribe, King Haigler, she might not have even received a Christian burial. He and some of his braves brought her body to the local Quaker meeting, and the people there buried her in their graveyard, where General Cornwallis interrupted his planning for the Battle of Camden to both pay for her tombstone and attend her funeral. There is no word if Lieutenant McPherson was in attendance; in fact, some versions claim that she did find her lieutenant, just in time to watch *him* die of yellow fever. Now, though I am far from a romantic, I am human and this tale does tug at the heartstrings. Facts may be silly things, but they are key to understanding past events. And the facts don't jibe in this account. First, King Haigler, while friendly to the early settlers at Camden, was killed by a Shawnee raiding party between 1763 and 1765 during the French and Indian War. Also, it is unknown when in 1780 Agnes arrived in Camden, and it is possible that the British had already departed. Finally, there is no mention of a Lieutenant Angus McPherson in service near Camden in 1780. Even still, an attractive young lady died on what was then the frontier and was kindly buried by strangers.

According to local lore, Agnes still walks near the Quaker Cemetery in which her body lies and near the historic Camden site along U.S. Highway 521 south of modern Camden. I have been that way many times and have never seen anything, and if you've read my other books, picking up a phantom hitchhiker is old hat for me. However, on my research trip to the Kershaw and Sumter County sites with my wife, Rachel, and our friend Erin Maloney,

Rachel—who responds to the supernatural with much less calm than I—was noticeably shaken while we were at the Quaker Cemetery. She refused to say why until we were headed home and safely past the area. She said she felt a weight of sadness bordering on grief while we were at the graveyard. She did not see anything, but when I offered to go back I was told *no* in no uncertain terms. Perhaps during our next visit.

THE CLEVELAND SCHOOL FIRE: GHOST LORE WITH A PERSONAL TOUCH

The haunting at the site of the Cleveland School in Kershaw County starts with a tragedy so severe that it was memorialized in song by the Dixon brothers, Dorsey and Howard. The Dixon brothers were millworkers from Rockingham, North Carolina, who were born in Darlington, as you may recall. "The School House Fire" was Dorsey Dixon's first composition and the one that started their careers as country musicians. However, the Cleveland School fire was also noteworthy for its role in changing fire safety standards nationwide for the better. Doors that open outward, exterior fire escapes, wider stairways and more use of flame-resistant construction material followed the deaths of seventy-seven people on May 17, 1923. The tragic thing is that the crowd had gathered for an end-of-the-year pageant prior to the closing of the school for the summer. The fire started in the second-floor auditorium when either an oil lamp or a candle was knocked into some draperies onstage.

The mass panic caused stairs and doorways to fill, the location of the auditorium on the second floor limited escape and the rural location of the school limited rescue. The school building burned to the ground, incinerating most of the victims. Of the seventy-seven who died, sixty-seven were buried in a mass grave measuring

forty by twelve feet in the cemetery at Beulah Methodist Church and are listed on a marker at the site. My wife's late grandmother, Marietta Thompson Wylie, lost several family members in the blaze. According to local lore, the unidentified dead still walk Cleveland School Road from the school memorial and scale reproduction—near the I-20 overpass and at which a monument lists all those who died so needlessly—to Beulah Church.

The ghosts seem to be looking for someone and vanish right after being seen. Of course, my wife and I visited this site while I was working on this book. We did not see anything unusual, but while at the monument, the noise of traffic from I-20 faded and the air grew still. After this change in the atmosphere, we both got back in the car, abandoning her plan to take a rubbing of the marker, and left. We did not speak until I asked if she wanted to visit the grave site; she said yes, so we stopped there. The atmosphere there was more like a normal hazy and muggy early fall South Carolina afternoon. We both said that we had no idea what was about to happen at the monument, but we were both glad that we had beaten a hasty retreat. The site is interesting to visit and, without any family ties, would be a great side trip to break up the run of I-20 across central South Carolina. But neither the wife nor I will tag along.

COOL SPRINGS PLANTATION: THE PARTY NEVER STOPS...

Cool Springs Plantation was built by William and Mary Boykin in 1832. The home stayed in the Boykin family until the mid-1970s. The haunting spirit is supposedly a former owner named Dixie Boykin, who died under suspicious circumstances if local gossip is to be credited. There were rumors that his second wife, who had already lost two husbands to accidents, neglected to give him some needed medication. The surviving children fanned

those flames for years. Mr. Boykin was a great entertainer and enjoyed good wine. According to published accounts, owners are sure to leave a glass of wine out for him before any party as a sign that he is welcome to attend. No mention is made of what occurs if the ritual is forgotten. Reports of a man wearing fashionable clothing of the prewar era have been made, as well as those of guests hearing music from the 1920s and 1930s from stereos that are off; a man is also heard humming.

Sadly, I could not gain an invitation to Cool Springs to verify that Dixie Boykin is still fond of his dram. Hopefully, unless you receive such an invitation, you will respect the rights of the present owners to be left alone.

THE COURT INN AT LAUSANNE MAY BE GONE, BUT IS THE GRAY LADY AS WELL?

The home that was once known as Lausanne was built in 1830 by Mrs. John McRae but was soon sold to descendants of the DeSaussure family. During this period, the building was home to a portrait of George Washington by a member of the Peale family that was given to Mr. John McPherson DeSaussure's grandfather by Washington himself. When news of Lee's surrender reached Camden in 1865, a party was scheduled for Lausanne. Upon hearing the news, Mr. DeSaussure's daughter lit the gaslights with Confederate money. In 1884, the house passed out of the DeSaussure family and Lausanne became known as the Court Inn. It drew its clientele from the northerners who came south for the winter. The building was finally torn down in 1964. The large stone lions that once decorated the front entry are now located in front of the South Carolina State Library building on Senate Street in Columbia.

The haunting is tied to the DeSaussure family more than the site itself and dates from the 1560s. According to the legend of

the Gray Lady, she was Eloise DeSaurin, who fell in love with a Huguenot during France's Wars of Religion. Her loyally Catholic father threatened to kill her beloved but relented and placed Eloise into a convent, where she died a few years later of a broken heart. Shortly thereafter, her mother died insane and her father called his surviving but estranged Huguenot sons to his deathbed. He stabbed himself with the same dagger he had threatened her lover with after telling his sons that Eloise had appeared to him. She is supposed to have cursed the family with her return any time that the family faced danger.

She next appeared to a brother, warning him of the approaching St. Bartholomew's Day Massacre and providing him with a monk's habit to wear while fleeing. When the family's descendants left France for the Carolinas, she came as well. She has appeared prior to the loss of a family heir to a hunting accident, on that occasion appearing to the man's fiancée rather than his doubting father. She also appeared during a fire at the Court Inn in the 1940s that caused the damage that led to its demolition in 1964, though not to a family member. After the demolition, sporadic reports of Eloise appearing throughout the subdivision that then occupied the grounds of Lausanne and the nearby parks have continued to surface, though most folklorists believe that Eloise has finally found peace. I have never seen Eloise, but I am not of Huguenot descent and the Court Inn was a memory by the time I was born. However, every time I drive through Camden I keep an eye out for a lady in a gray habit, just in case. I also think that she was tied more to the DeSaussure bloodline and that the nonfamily sightings are the product of the usual overactive imagination. There is a long history of both noble and royal houses in Europe having death omens, many of which are represented by female relatives dressed in distinctive colors such as gray, white and black. So this story is not as far-fetched as you might think.

THE CRAVEN HOUSE

The house now known as the Craven House at Historic Camden was originally located on Mill Street and was built about 1789. In fact, it is only one of two houses in Camden that date to before 1800 and are still standing. This distinction is due to Lord Rawdon, the British commander who set fire to the town upon his retreat in May 1781. The house is named for the first known owner, John Craven, who was an accountant and handled the finances of Colonel Joseph Kershaw, namesake of Kershaw County. The house is thought to be the site of a dinner given for President George Washington by the citizens of Camden during his southern tour on May 25, 1791. John Craven last appears in the records in 1817, when he is referred to as a lunatic. The house was given to Historic Camden in 1970 by Mr. and Mrs. Richard Lloyd, and it was restored and furnished with period furniture, despite the uncertainty of it originally having served as Craven's home or office. The house and its ghost were featured in an article in *Fate* magazine in 1961.

The haunting at the Craven House is centered on what served the most recent private owners as the kitchen. During renovations, an old broad-headed axe was found in the walls, and an old flintlock rifle was found in a small shed on the Mill Street site as well. Some theorize that these items may be tied to the haunting and may have triggered it. In any case, the haunting was marked by a roving cold spot, doors that would not stay open or closed and footsteps. The kitchen was the site of strange sounds, like firewood being thrown onto the floor with great force, only to have none be present upon investigation. Odd-looking animals and the mysterious falling of stones were also reported, but I will leave those for folks with a more Fortean turn of mind than mine. Sadly, the staff member working on the day that I visited seeking ghost stories had not had any odd experiences in his years of working at the site and was surprised to hear the story. I toured the site and

lingered at the Craven House, to no avail. I recommend Historic Camden to you, for both historic and ghostly reasons, since that organization also maintains the Quaker Cemetery, home of the bones of Agnes of Glasgow.

GENERAL DE KALB: READY TO BE REMEMBERED?

This story is almost humorous, in a macabre sort of way. Johann von Robaii, Baron de Kalb, was born Johann Kalb in Bavaria in 1721. After serving in the French army in several European conflicts, he came to offer his aid to the fledgling American army with his protégé, the Marquis de Lafayette, in 1777. Just before he departed for France in a huff at being refused a commission, he was commissioned a major general and sent to the aid of Charleston. Upon Horatio Gates being named as commander of all American forces in the South, Kalb was assigned to his army. During the Battle of Camden (actually fought northwest of town), he had a horse shot out from under him and received three gunshot wounds and at least eight wounds from British bayonets. Despite being treated by Cornwallis's own surgeon, Kalb died of his wounds on August 16, 1780. He was buried on the site of the battle with honors due his rank by his captors. However, when Lafayette made a triumphal tour of the former colonies, he was invited to lay the cornerstone of a more fitting monument to his deceased mentor. The monument was placed in the cemetery of Bethesda Presbyterian Church and was designed by Robert Mills. According to oral traditions, Kalb bodily rose from his grave, walked to the site of the monument and buried himself. No other sightings are mentioned of this rather bizarre sight, either before or after the dedication. However, in case you pay a visit to either the battle site or his grave, keep an eye out.

THE HEADLESS HORSEMAN OF HOBKIRK'S HILL: THIS AIN'T HOLLYWOOD, FOLKS

As mentioned previously, the Battle of Hobkirk's Hill in April 1781 was one of the last gasps of organized British warfare in South Carolina. Following his tactical victory but strategic defeat, Lord Rawdon, the British commander of the forces at Camden, fired the city and withdrew to Charles Town, leaving most of inland South Carolina in Patriot hands. By the end of October 1781, Cornwallis would be an American prisoner, and except for the odd mopping-up action such as seen at Eutaw Springs in September, the war would be over. Of course, the rebuilding and reconciliation would take a bit longer. For some, the memories of war would linger, aided by the sight of a bizarre specter.

The account of the headless horseman of Hobkirk's Hill has been documented since the late nineteenth century. In fact, some have tried to suggest that the Hobkirk's Hill account influenced Washington Irving during the writing of *The Legend of Sleepy Hollow*, despite any evidence to support the theory. The unfortunate horseman did serve as inspiration for a scene in which a poor soldier is beheaded by a cannonball in the *The Patriot*, the 2000 film starring Mel Gibson, which was filmed in nearby York and Chester Counties. However, in the case of our unknown and luckless horseman—so unknown that no one is sure for which side he fought in the battle—it was all too real. Most sources claim that he was a British sentry killed in the Patriot counterattack, but some state that he was a Patriot cavalry officer who was struck and decapitated while his horse continued to charge into the Black River swamp, where the poor animal drowned.

According to local lore, if the swamp is shrouded by a misty fog on a spring night with a full moon, you may see a skeletal horse arise from the muck, with a headless figure on his back, and gallop around the swamp and into a nearby cemetery. Then, at daybreak,

both mount and rider return to their watery tomb. As much as I want to, I haven't yet seen this poor soul, but I trust that patience will pay off at some point. And, yes, I will try to get close enough to figure out for which side he fought.

MOUNT PISGAH BAPTIST CHURCH

Trying to locate Mount Pisgah Baptist Church took a comparatively long time because it, like so many reputed church hauntings, was physically located in one county but had a mailing address in another. An example of this is mentioned regarding Prospect Methodist Church in the Chesterfield County chapter. Once I found it, Mount Pisgah Church looks like hundreds of other rural, brick Baptist churches throughout the South. However, if online sources are to be believed, this church is home to several ghosts. Unusual for most of the other church hauntings in this book, the haunting at Mount Pisgah is centered inside the building. Feelings of being watched or followed when alone, the sounds of footsteps and children playing on the second floor, especially, and the sighting of a figure in a deserted balcony in the sanctuary have all been reported by various witnesses. Of course, when I called the church seeking verification, the stories were denied and my request to visit one evening was refused. I am inclined to write off this story as a means to scare kids during a lock-in, but I do wonder if there's fire behind that smoke.

MULBERRY PLANTATION

The land that is now the site of Mulberry Plantation was granted in 1750 by King George II to the first James Chestnut. The current structure was built in 1820 by the second James Chestnut. The

house is best remembered for being the home of the fourth James Chestnut and his wife, Mary Boykin Chestnut, the famed Civil War diarist. The plantation was named a National Historic Landmark in 2000. It is unclear what connection the Chestnut family has with the ghost of Mulberry Plantation. According to local lore, a white stallion dashes through the pines at twilight. I have found only one source for this story, and Mrs. Chestnut does not mention any ghosts at Mulberry in her diary. On my two trips past Mulberry, both of which occurred at the appropriate time, I saw no trace of a white horse, living or dead. Of course, I could not gain access to all of the more than four thousand acres, as Mulberry is private property.

PAINT HILL: DOES ROCHELLA BLAIR STILL ROAM?

The story of the Blair family was checkered by high political achievement and violence both offered and accepted. Rochella Blair's maternal grandfather was hanged for murdering a neighbor following a dispute over some property. Her paternal grandfather, James Blair, served as congressman from the district including Kershaw County from 1821 to 1822 and from 1829 to 1834, as well as sheriff of Lancaster District beforehand. Congressman Blair killed himself for still-unknown reasons. Her father, Major L.W.R. Blair, was falsely accused of murder just before the Civil War. Despite this, he served in the local militia during the war, rising to the rank of captain, and became active in politics, editing the *Kershaw Gazette* newspaper, generally opposing any fusion of the white Democrats and Republicans and supporting Wade Hampton's racial views. However, in 1880, he spilt from his party over monetary and livestock fencing policy and was nominated as an Independent for governor. He lost the election to Johnson Hagood, the regular Democratic nominee. By 1882, Blair was a major champion of political equality and a serious threat to further white rule of the state.

On July 4 of that year, after addressing a crowd of black supporters, Blair was shot by James Haile, who was shortly acquitted and elected sheriff of Kershaw County, serving for the next ten years. Shortly after her father's murder, Rochella committed suicide by taking poison. People have reported seeing a young lady in distress wearing a white dress, walking between Town Creek and SC Highway 34, east of Camden. When approached, she vanishes. I have not seen Rochella yet but I still have hope. There seems to be no restriction on when she appears, though I would expect late August and early September would be the best options. Good luck.

RECTORY SQUARE PARK: DO CAMDEN'S SIX GENERALS STILL RALLY THE TROOPS?

The final haunting in Camden is among the least documented. According to one source, the sounds of drums beating a call to arms followed by several full-throated "Rebel yells" ring out over Rectory Square Park in downtown Camden. This park is home to a Pantheon dedicated to Camden's six Confederate generals: Cantey, Chestnut, Deas, Kennedy, Kershaw and Villepigue. The only one not to survive the war was John B. Villepigue, who died of a fever in 1862. The Pantheon is a pergola, or gazebo, supported by six concrete columns, each of which bears a bronze plaque honoring a general. No apparitions have been seen at the site, but the voices and drums are heard after dark year-round. I have heard neither drums nor yells yet, but I think it is just a matter of being in the right place at the right time.

LEE COUNTY

Lee County was formed in 1902 from parts of Darlington, Kershaw and Sumter Counties. It was named for the Confederate commanding general Robert E. Lee. It is bordered by Sumter, Kershaw, Chesterfield, Florence and Darlington Counties. Since its creation, it has remained intact. The county has given South Carolina one governor, Thomas McLeod, and one U.S. senator, Ellison D. "Cotton Ed" Smith. At the time of his death in November 1944, Senator Smith was both the oldest and longest-serving senator, having been first elected in 1908. He is best remembered today for walking out of the 1936 Democratic National Convention when an African American pastor gave the invocation and for opposing ratification of the Nineteenth Amendment, which essentially gave women the right to vote, out of fears that its passage would allow for more African American voting. He was also renowned for his stump oratory, to which he owed victories in three separate runoffs. His racial stance is rather ironic in retrospect, given that the majority population of both major towns in Lee County is now African American and likely was then as well. Other notables from Lee County include Felix "Doc" Blanchard, the 1945 Heisman Trophy winner from West Point known as "Mr. Inside." As of this writing, he is the oldest living

Heisman Trophy winner. One Revolutionary War action occurred in the county. Lee County saw more action in the Civil War, with two skirmishes taking place in the area. Bishopville is the site of the South Carolina Cotton Museum, which details the role played by this crop in the history of the state.

MORE TO SCAPE ORE THAN THE "LIZARD MAN"

Though not a ghost, the reputed paranormal and cryptozoological origins of the Lizard Man of Scape Ore Swamp, not to mention his notoriety, demands his inclusion in this book. The description found in eyewitness accounts is familiar enough, especially to those of us who were here for the original wave of sightings in the summer of 1988. The Lizard Man is described as being seven feet tall, bipedal and well built, with green, scaly skin and glowing, orange eyes. It is said to have three toes on each foot and three fingers on each hand, which end in a circular pad that can stick to walls. Some reports mentioned smelling a foul odor, like wet dog hair and rotting vegetables. Various witness over July and August 1988 reported sightings, three-toed footprints over a foot long and scratches and other damage to cars parked near Scape Ore Swamp near the Lee/Sumter County line.

Most experts now think that the Lizard Man was a hoax and that the sightings were of a diseased bear. But then again, have any experts ever said that the unusual or unexpected could be exactly what folks thought it was? Sadly, though I spent a weekend in Bishopville at the height of the Lizard Man hysteria, along with most of the population of the Southeast, I never saw anything or had any encounter at all. However, it made this sixteen-year-old's summer.

There is more to Scape Ore Swamp than the possibility of seeing South Carolina's answer to Bigfoot. According to one local legend, the swamp was first called Escaped Whore Swamp from an almost

humorous encounter during the Revolution. One evening, some British regulars were "entertaining" some ladies of doubtful morals when a small band of General Francis Marion's men attacked, killing the British and cursing the ladies to roam the swamp for eternity. I will say, however, that some sources deny this version and claim that the name comes from a hunting guide's mispronunciation of the phrase "escaped over" in relation to a fleeing deer in the swamp. The fact that no record exists of the fight favors the second view. The glimpse that I had of a flash of white among the trees when passing the site leads me to favor the first. I'd have to visit the site further before making up my mind.

MARION COUNTY

M arion County was formed in 1785 from Georgetown County and was named for General Francis Marion. It lost territory to Florence County when that county was founded. It is bordered by Dillon, Horry, Florence and Marlboro Counties. The county was the site of two skirmishes in the Revolution, not counting the action at Bass's Mill on the Dillon County line. The only Civil War site of note is a Confederate Naval Yard on the Pee Dee River, where a wooden gunboat, the CSS *Pee Dee*, was built in November 1864; sadly it was burned in March 1865 to prevent Federal troops from seizing it. The town of Mullins is home to the South Carolina Tobacco Museum, detailing the key role that this now maligned plant played in the state's economy for decades. Marion County has been the home of one governor, William Ellerbe, who died in office after winning a second term at age thirty-seven. He was also the first governor to be elected under the Constitution of 1895, which largely disenfranchised a majority of black voters. Lieutenant General James Dozier, longtime South Carolina adjutant general and Medal of Honor winner in World War I, was born in Marion. Lucile Godbold—the first woman in the South Carolina Athletic Hall of Fame and winner of gold medals in the shot put and the hop, skip and jump events at the 1922 Women's Olympics in Paris—was also born in Marion County.

PEGGY: STILL AT THE GALLOWS?

Despite the long history of English settlement in the Marion County region, the only ghost story I could find for the area came about completely by accident and has not previously been documented to my knowledge. On the late fall Saturday afternoon when I arrived in Marion to research this chapter, I expected to find the usual musty write-ups of once-seen spirits from old newspaper clippings or a brief, passing mention of a haunting in an oral history, as is so often the case. I surely did not expect to see a ghost in the center of town. When I pulled up to the Marion County Library, I noticed a quick flash of unexpected color to my left. When I turned, I saw a tall, slender, young African American lady dressed in antebellum clothing. She looked down and faded from sight before my eyes, like an image on a blown television picture tube. Naturally, this shook me up and I gaped, mouth ajar, for a few seconds. Then I shook my soaked head and went inside. The library worker on duty, noting my shock, asked what was the matter. When I described my sighting, she smiled and said, "You've met Peggy," like it was an everyday event.

She then handed me a copy of Nancy Rhyne's *Voices of Carolina Slave Children* and turned to a story concerning the hanging of a vengeful house servant belonging to the Scott family. Due to either actual or perceived mistreatment, Peggy attempted to poison the Scotts' morning coffee and was detected. She was sentenced to be hanged, and naturally, all the local slave owners sent their slaves to watch the execution. The account describes Peggy as sitting on her coffin before the crowd prior to the hanging and then being placed in it afterward. The library worker told me that Peggy has been seen several times since, mainly by tourists or other nonlocals. As much as it pains me to admit, my state led me to thank the lady and leave without getting her name. She has my thanks once again.

WOODLAWN PLANTATION

Woodlawn Plantation was built in 1853 by the LeGette family. In what I am sure was unintended irony, the house was designed by a free black from Philadelphia and built by slaves. Sadly, none of the records mentions the designer's name. Reverend David LeGette, the builder of Woodlawn, his wife, Martha, and their eldest son, Captain Hannibal LeGette—who, as it happens, died in the house from wounds received in battle in the Civil War—have all been seen at the house by past owners, according to several sources. However, the current owners have an unlisted number and I decided not to breach their privacy. I hope you will be as understanding.

MARLBORO COUNTY

M arlboro County was formed in 1785 and is an original county, with boundaries unchanged since its founding. The county was named for John Churchill, the first Duke of Marlborough. The county is bordered by the state of North Carolina and by Chesterfield, Darlington, Florence and Dillon Counties. The county was the site of three skirmishes in the Revolution but was the site of a "camp of repose" for General Nathanael Greene's army in December 1780. These skirmishes include the occupation of the county seat of Bennettsville by Sherman's forces in March 1865, while his troops were en route to North Carolina. Surprisingly, the home of former United States and Confederate congressman John McQueen in Bennettsville was not disturbed. Blenheim Ginger Ale was originally bottled in Blenheim, South Carolina, with the local mineral water and is now bottled in Hamer, South Carolina, the home of South of the Border. A warning to the curious, however: Blenheim Ginger Ale is not Canada Dry or Schweppes. Approach with caution but enjoy.

Marlboro County was home to two U.S. senators, Josiah Evans and John McLaurin. Senator McLaurin is best remembered, if at all, for engaging his colleague "Pitchfork Ben" Tillman in a fistfight on the Senate floor in 1902. Despite winning the secret admiration

of many of his colleagues and fellow politicians in South Carolina, the brawl and subsequent censure ended his career. The county has also given South Carolina two governors, Barnabas Henagan and John L. Wilson. Governor Wilson was also the author of *The Code of Honor*, which listed proper behavior for principals and seconds in duels. Other notables from Marlboro County include Hugh McColl, former president of Bank of America, and Marian Wright Edelman, president and founder of the Children's Defense Fund and the first African American admitted to the Mississippi Bar. Another notable native from Marlboro County was David C. Roper, President Franklin Roosevelt's first commerce secretary and later ambassador to Canada in 1939. The president of Wofford College during the Civil War and noted historian of Methodism Albert Shipp also lived in Marlboro County.

BACK TO BINGHAM'S LIGHT…THIS TIME BY WAY OF BLENHEIM

What I referred to exclusively as Bingham's Light in the Dillon County chapter has actually been seen at various points in a rough corridor along SC Highways 38 and 34 between the communities of Blenheim in Marlboro County and Bingham in Dillon County. In Marlboro County, the version of the explanation for the light's existence is the father with a lantern searching for his children, all of whom were lost in a blizzard in the early 1800s. The primary change is an admonition not to pursue the light if sighted, as it will approach you. Witnesses have reported that the main point of access is posted and that there are now several cellular phone towers nearby that may lead you astray, so as always, be aware of your surroundings. Some witnesses warn that you may also be confused by headlights and taillights from traffic on SC 34.

POOR COLONEL KOLB: WHY MAKE THE FAMILY SUFFER?

First, to clear up any confusion, Colonel Abel Kolb and General Baron de Kalb are two different Revolutionary War figures. Colonel Kolb was active as a partisan Whig leader in the modern Marlboro and Darlington County area, whereas General de Kalb, whom we have already met, died for American Independence at the Battle of Camden. Colonel Abel Kolb led retribution parties on behalf of the pro-independence Whig faction. This activity finally caught up with him on the night of April 27 and on into the next morning.

A large number of Tories decided to decapitate the Whig leadership in a massive raid. Colonel Kolb was their prime target. His home was surrounded and, according to some sources, was actually set on fire, despite the presence of innocent women and the determined resistance of Kolb and a few other men. However, Kolb was outnumbered and decided to surrender, after a promise of safe conduct and protection for the ladies present. Sadly, he was shot, against orders, while in the process of handing his sword over. Thankfully, though the house was sacked and burned, no other insult was done to either the ladies or Colonel Kolb's body. Fortunately as well, the statement that both he and his family were burned to death in the fire is false.

According to some sources, the tomb of Colonel Kolb is haunted. If you visit it on a fall night, you may hear the sound of footsteps approaching through the fallen leaves. If you are especially lucky, you may even see the figure of the man standing near the stone. On my visit, the footsteps I think I heard may have been the breeze, but the site would certainly repay another visit. Please treat it and all grave sites with the respect they are due.

CHAPTER 12

RICHLAND COUNTY

R ichland County was established in 1785 and is bordered by Kershaw, Fairfield, Lexington, Calhoun and Sumter Counties. The county was named by early settlers in reference to the "rich land" found along the many rivers in the area. The Native American presence in the county dates back to the beginning of the Common Era, with the main tribes being the Cherokees, Catawbas, Congarees and Waterees. The area mainly served as a neutral hunting ground, although during the 1760–61 Cherokee War, John Pearson built a private fort in the northern part of the county. However, there is no record of any hostile activity in the area due to a fairly small population. Prior to the Revolution, several major trading paths passed through the county. Although no Revolutionary War battles occurred in the county, President George Washington did spend several nights in the area during his southern tour in 1791. Also in 1791, Richland County lost territory to Kershaw County upon the latter's establishment.

In 1786, the capital of South Carolina was relocated from Charleston to Columbia, the first planned city in South Carolina and the second in the United States, following Savannah, Georgia. As the site of the capital of South Carolina, Richland County was an epicenter of both the nullification and secession crises. On

December 17, 1860, the First Baptist Church in Columbia was the site of the first meeting of the Secession Convention held following Lincoln's election in 1860, though a rumored smallpox outbreak led to an adjournment and reassembly in Charleston. Some scholars believe that the outbreak rumors were the product of the fears of secessionist leaders that Columbia's atmosphere would be too moderate to declare for immediate action.

For most of the Civil War, Columbia served as a manufacturing and political center for the Confederacy, though a prisoner of war camp, Camp Sorghum, was located outside the city. However, the fall of Savannah in December 1864 opened up South Carolina to Sherman's advancing troops. As the "Cradle of Secession," the state feared what retribution Sherman would exact, but most (including both civil and military authorities) felt that Charleston would be hardest hit. After feints toward both Charleston and Aiken, Sherman's army headed north toward Columbia. The city surrendered on February 16, 1865, after Union troops shelled the statehouse then under construction, leaving scars that are now marked by six bronze stars on the marble walls of the reconstructed building. Sadly, for the student of antebellum architecture, on February 17, 1865, Columbia was in flames.

The debate over who was responsible for the blaze has persisted since the last ember was doused. Some scholars placed the blame on Confederate commander Wade Hampton III and claimed that he ordered cotton stored in the city set alight to keep it out of Union hands. Strong winds and dry weather did the rest. As Hampton was a Columbia native and later served as governor and U.S. senator from South Carolina, I doubt his culpability for the inferno. The more commonly held theory is that some of Sherman's troops, after being discovered in the act of looting, set the blaze to cover their tracks, and the wind and weather then caused the flames to burn out of control. Although most scholars blame "the Yankees" for the fire, the most popular rationale is that it was set in revenge

for the leading role played by the state in the sectional crises of the previous half century or so. The fact that some of Sherman's men inquired about the location of the First Baptist Church before the fire lends some credence to this view. Over one third of the city's buildings were lost, including most of the government offices and the business district. Other Confederate generals with Richland County ties include Maxcy Gregg, born in Columbia, and states rights activists Gist, Ellison Capers and J.S. Preston, all of whom are buried in Columbia.

During Reconstruction, the city was a focal point of attention, as South Carolina was one of the few states to have a black majority legislature; a black attorney general, Robert Elliott; two black lieutenant governors, Alonzo Ransier and Richard Gleaves; and a member of the state supreme court, Jonathan Wright. In the disputed election of 1876, Columbia was a key player in the struggle both to end Reconstruction and to resolve the presidential election. In South Carolina, the 1876 election was rife with fraud on both sides. The Republicans counted the Democrats out, and the Democrats ran a campaign of intimidation in both the gubernatorial and presidential races. The state was witness to the spectacle of two men claiming to be governor—the Democratic challenger, General Wade Hampton III of Civil War fame, and the incumbent Republican governor, Daniel Chamberlain. Two general assemblies, known as the Wallace and Mackey Houses after the respective Speakers of each house, were battling it out as well. The South Carolina Democrats gave in to Republican demands that they keep the White House in return for the end of the presence of Federal troops in the state and the promise of Federal noninterference in state elections, which spelled doom for the hopes of Republicans electing a governor for almost another one hundred years. Hampton and the Wallace House were duly recognized as the official state government and the redemption of the state was complete.

As the site of the state capital, Richland County is home to several educational institutions. These include the University of South Carolina (USC), Columbia College, Allen University, Benedict College, Midlands Technical College, Lutheran Theological Southern Seminary and Columbia International University. Most, if not all, federal and state agencies are based out of Columbia due to its position as state capital and its central location in the state. All state governors since 1790 have lived in Columbia, though only three were born in Richland County—John Taylor, who also served as U.S. senator; James H. Adams; and Duncan C. Heyward, who wrote *Seed from Madagascar*, which discussed rice planting in South Carolina. Wade Hampton III, who also served as both governor and U.S. senator, was born in Charleston but called Columbia home from 1838 until his death in 1902. James F. Byrnes—who served as U.S. senator, governor of South Carolina, U.S. secretary of state and as an associate justice of the U.S. Supreme Court, as well as in several New Deal–era federal positions—spent his latter years in Columbia and is buried at Trinity Episcopal Church Cemetery. As a small boy, future president Woodrow Wilson lived in Columbia from 1870 to 1874, while his father served on the faculty of the Columbia Theological Seminary. The home he lived in is a National Historic Site and noted tourist attraction.

Other notable attractions in Richland County include Fort Jackson, the largest Initial Entry Training Center in the U.S. Army and the only military base located inside the city limits of its host city. Fort Jackson was named for seventh president (and South Carolina native) Andrew Jackson. Columbia is also the only southeastern city with direct access to three interstate highways: I-20, I-26 and I-77. Interstate 77's southern terminus is located near the Columbia Metropolitan Airport, and the highway runs to Cleveland, Ohio. Near the community of Hopkins in the southern part of the county is South Carolina's only national park, Congaree National Park. Two other major attractions in the Columbia area are the

Riverbanks Zoo and Garden and the South Carolina Statehouse grounds—home to some rather unique monuments, including the first monuments on the grounds of any statehouse dedicated to the contributions of African Americans to the state heritage. There is also a large monument in honor of the Confederacy, which, regardless of one's politics, is appropriate given South Carolina's role in secession and the Civil War. Another interesting monument on the statehouse grounds is the grave of Captain Swanson Lunsford of Virginia, a veteran of the Revolution, which was the only grave located on the grounds of a U.S. state capitol until the interment of U.S. senator Huey Long at the new state capitol at Baton Rouge, Louisiana, in 1935.

Noted athletes with ties to the area include Kirby Higbe, a two-time All-Star pitcher in the 1940s with several teams, especially the Brooklyn Dodgers. Higbe was traded to the Pittsburgh Pirates in 1947 after refusing to play with Jackie Robinson, the first African American to play in the Major Leagues in the twentieth century. Past and present National Basketball Association standouts from the area include Alex English, longtime member of the Denver Nuggets and member of the Basketball Hall of Fame since 1997. National Football League players with ties to Richland County include George Rogers, winner of the 1980 Heisman Trophy, who played for both the New Orleans Saints and Washington Redskins. Rogers was a two-time NFL All-Pro and a member of the Super Bowl XXII–winning Redskins squad. He is also a member of the College Football Hall of Fame.

Dan Reeves, who played his entire career for the Dallas Cowboys and won one of the two Super Bowls in which he competed—though he lost the four Super Bowls in which he served as head coach—played quarterback for the University of South Carolina. As a head coach, Reeves won three American Football Conference crowns with the Denver Broncos and one National Football Conference crown with the Atlanta Falcons.

He also served as head coach for the New York Giants for three seasons. He was the first opposing head coach to win a playoff game at famed Lambeau Field in Green Bay and a two-time winner of the NFL Coach of the Year Award, in 1993 and 1998.

Other coaches with ties to Richland County institutions include Bobby Cremins, who played basketball for USC before coaching at Georgia Tech and the College of Charleston, and Bobby Richardson, longtime baseball coach at USC, member of the New York Yankees dynasty in the 1950s and a native South Carolinian. Notable head football coaches at USC include Lou Holtz, Joe Morrison, Steve Spurrier and Jim Carlin. Frank McGuire, longtime head basketball coach at USC, was the only coach to take teams to both the Final Four of the Men's Basketball Tournament and to the College World Series (while at St. Johns). He won the 1957 Men's Basketball NCAA Championship while at North Carolina before coming to USC. He is still the winningest men's basketball coach in school history. One other notable athlete from Richland County should be mentioned, as well. Lillian Ellison, better known as the "Fabulous Moolah," a longtime women's professional wrestling champion, was born in Columbia.

Notables from the arts with Richland County ties include director and choreographer Stanley Donen. Mary-Louise Parker, star of such films as *Fried Green Tomatoes* and *Boys on the Side* and television series including *The West Wing* and *Weeds*, was born at Fort Jackson. Noted muralist and sculptor Blue Sky, formerly known as Warren Johnson, works in Columbia. Two-time Grammy-winning band Hootie & the Blowfish was formed by a group of young University of South Carolina students. This racially mixed band followed about sixty years after Columbia's first big splash in pop culture. In the late 1930s, a dance known as the Big Apple arose from the nightclub of the same name in Columbia. The dance is similar to the Lindy Hop and the shag and is a modified line dance. Tommy Dorsey recorded a song of the same title that sold well. It is one of the few dances that have been honored with a State Historical

Marker. Kimberly Aiken, the first African American Miss South Carolina, was named Miss America in 1993.

Authors with Richland County ties include James Dickey, author of the novels *Deliverance* and *To the White Sea* and poet-in-residence at the University of South Carolina; Henry Timrod, known as the "Poet Laureate of the Confederacy," who lived in Columbia briefly at the end of the Civil War; and J. Gordon Coogler, father of the "cooglerism" typified by the famed couplet, "Alas, for the South! Her books have grown fewer/She never was much given to literature" and known for "poems written while you wait." His only published work, *Purely Original Verse*, was published in 1891 and is a hoot. I would be remiss if I failed to mention Columbia native T.F. Hamlin, winner of the 1956 Pulitzer Prize for biography for his work on architect Benjamin Latrobe.

Other fields in which folks with Richland County ties have excelled include the law, education, religion and aviation. Notables in the legal field include Jean Toal, the first female justice and chief justice of the South Carolina Supreme Court and first native of Columbia to hold the position; Matthew Perry, the first African American federal judge from the Deep South; and Isaac S.L. Johnson, one of the first African American graduates from the University of South Carolina Law School and one of the first African Americans to be elected to the South Carolina General Assembly as a Democrat. In the field of aviation, Columbia natives include astronaut Charles F. Bolden Jr., veteran of four space shuttle missions, and Paul Redfern, pioneer aviator, who was the first man to fly solo over the Caribbean and who made the first nonstop flight from North America to South America. Paul Redfern was attempting to fly from Georgia to Rio de Janeiro when his plane apparently crashed somewhere in Venezuela in 1927. In the field of religion, Joseph Cardinal Bernardin—the Catholic archbishop of Chicago from 1982 to his death in 1996—was born in Columbia. He was elevated to the College of Cardinals by Pope John Paul II in 1983.

THE UNIVERSITY OF SOUTH CAROLINA: SPOOKY STACKS, CREEPY CATACOMBS AND OTHERS

The University of South Carolina was established at Columbia in 1801. Over the last two centuries, it has transformed from college to university and back again. Brilliant nineteenth-century scholars like Francis Lieber and Thomas Cooper have been followed by other, more diverse, minds like Jehan Sadat, Charles Bierbauer, Havilah Babcock and Cleveland Sellers. The then-named South Carolina College was forced to close during the Civil War, with the buildings serving as a hospital. During Reconstruction, it was reopened as an integrated university but was badly buffeted by the changing political winds of the late nineteenth century. In 1906, it was rechartered as the University of South Carolina. Peaceful integration occurred in 1963, and the university is now a highly diverse cornerstone of both education and development in the state. Of course, with thousands of students and faculty passing through over the years, one would expect the campus to have at least one ghost, and one would be right.

Before we get to the ghosts on campus, I want to cover perhaps the best-known oddity on campus: the Third Eye Man. This entity, for lack of a better word, was seen in the maze of utility tunnels under the campus known as the "Catacombs" from the late 1940s to the 1970s. In the decades since, most of the tunnels have been sealed and access is strictly limited. The first sighting occurred in the fall of 1949 when a man dressed in silver was seen entering a manhole near the Longstreet Theatre. The next spring, the mutilated remains of two chickens led to a second encounter, in which the witness, a university policeman, claimed to have seen a man dressed in silver with a deformed face. The chief deformity was a small eye located in the center of the man's battered forehead. The policeman, naturally upset by this, allowed the figure to escape. After about fifteen peaceful years, the Third Eye Man made his

return in the late 1960s. A group of fraternity members were going to use the tunnel near Gambrell Hall for an initiation when one of them was attacked by a man in silver with a lead pipe. After suffering from shock and minor injuries, the students reported the incident to campus police. After nothing was found, the Catacombs were declared off-limits to all students and faculty. Despite my best efforts, the university refused to allow me access to the tunnels and claimed that the previous incidents with the Third Eye Man were either hoaxes or products of "mass hysteria."

A haunting on the USC campus is also connected with a former university president, who is buried on the Horseshoe area of campus near the museum that now bears his name. J. Rion McKissick served as USC's president from 1936 until his death in 1944. The former president has been seen on the balcony of the South Caroliniana Library, where he also is known to scatter books and papers. During bicentennial celebrations in 1976, both he and General Wade Hampton were supposedly seen reading news coverage in McKissick Museum on campus. I have been to USC dozens of times for meetings and workshops over the years and have never seen President McKissick or met anyone who has. However, I feel sure that his presence lingers over the university that he loved.

The last story at USC concerns a Columbia lady who was forced to serve as a nurse in one of the dorms after the Union occupation and burning of Columbia in 1865. She was raped but forced by her destitute family to return. She gained revenge by poisoning the invalids in her care. Even now she may appear to "Yankees" and offer them a glass of tea. Sadly, every building on campus that was extant at the time has been claimed as the site of this tragedy, and it has never been verified. Even still, if a young beauty in period clothing offers you some tea while on campus and you hail from a state north of Virginia, respectfully decline, just in case.

THE STATEHOUSE AND GROUNDS: TOOK A LICKING

The haunting of the statehouse grounds is localized near a ginkgo tree on the grounds. Some sources say that a few of Sherman's soldiers are to blame for the pushes and shoves people have felt, while others say that Captain Lunsford may be responsible. But by far the better-known haunting at the statehouse is centered near the rotunda. According to legend, prior to major renovations in the 1960s, tourists and workers could access the underside of the dome more easily than currently. Either a workman or young student fell from the edge of the rotunda to the marble floor below, leaving an indelible bloodstain still present under the carpet there. People have reported hearing a man's voice describing the fall and the sound of heavy running footsteps that echo like hard soles on marble, stories that lend more credence to the workman falling than the boy. I have visited both the grounds and statehouse itself numerous times and have not encountered either of these spirits. But I hold out hope, in echo of the state motto.

THE STATE MUSEUM: OF COURSE THE STATE'S ATTIC IS HAUNTED

According to several sources, the South Carolina State Museum is haunted by at least four separate ghosts, two of whom date back to its days as an active textile mill and are focused on the old freight elevators. The first ghost is reputed to be a worker who fell down the shaft and was decapitated. He has been seen just before closing exiting the elevator, carrying his head in his hands. As he walks down the corridor, he vanishes. The other gentleman has been seen entering the elevator and starting it, heedless of anyone waiting. If the elevator is recalled immediately, it is empty, even without

reaching another floor. Another aspect of the haunting is an audible banging on the old iron pipes that are suspended from the ceiling and are currently only decorative. Other ghost sightings include reports of a young African American woman in dust-covered mourning near an exhibit of a cooling board, used when funerals were mainly held at private homes. My personal favorite sighting is of a male figure in denim overalls near the replica of the CSS *H.L. Hunley* submarine. Upon being seen, he stepped toward the replica and vanished. Needless to say, that shortened my visit immensely.

HAUNTED HISTORIC HOMES

Ainsley Hall, a rich Columbia merchant, built what is now known as the Hampton-Preston House in 1818. A few years later, it was purchased by the first Wade Hampton. Both his son and grandson, each also named Wade Hampton, lived in the house at times, though Wade Hampton I's daughter, Caroline Hampton Preston, and her husband actually owned it until 1865. During the occupation of Columbia by Union forces, it served as the headquarters for Major General John "Black Jack" Logan, whose ghost is supposed to haunt the former home of the U.S. Senate Military Affairs Committee, of which he was chairman following the war. The home is on the National Register of Historic Places and is maintained by the Historic Columbia Foundation, which has run the house as a museum since 1970. Admission is charged and it is open to the public. No identity has been established for the ghost that has caused many malfunctions of audio and video recording equipment, candles that have been extinguished to relight and is the source for loud moans and shaking chandeliers inside the house. I have been to several meetings at the Hampton-Preston House, as well as taken the tour, and I have seen and heard nothing out of the ordinary. You may have better luck.

The Robert Mills House, also built by Ainsley Hall in 1823, was designed by (but never the home of) Robert Mills, designer of the Washington Monument and most of South Carolina's surviving nineteenth-century courthouses. The home was used as the site of the Columbia Theological Seminary until 1927. Both President Woodrow Wilson's father and uncle taught at the seminary while it was in Columbia and located at the Mills House. It, too, has operated as a historic house museum, run by the Historic Columbia Foundation since its renovation in 1967. The ghost here is much less active than the one at the Hampton-Preston House. The haunting seems to be focused on a second-floor bedroom, where staff members have found the imprint of a figure on an empty bed. During my one visit to the Mills House, I did not notice anything unusual, but I have since heard that the imprint is most often seen at opening and I visited in the mid-afternoon.

SUMTER COUNTY

S umter County was founded in 1798 by merging Clarendon County with the ghost counties of Salem and Claremont. It lost territory to the reestablishment of Clarendon County with its original boundaries in 1855 and upon the founding of Lee County in 1902. It is bordered by Richland, Calhoun, Clarendon, Florence, Lee and Kershaw Counties. Modern Sumter County was the site of one Revolutionary skirmish and suffered a serious loss of records in an 1802 fire that also destroyed early documents for the original Clarendon County and all records from Salem and Claremont Counties. The Civil War, especially Potter's Raid, had a sizable impact on the county due to its role as a railroad junction. Albert Haynesworth, a Sumter native, is credited with firing the first hostile shot of the Civil War in February 1861, when the cannon he was manning as a Citadel cadet fired on the *Star of the West* supply ship that was heading for Fort Sumter. The city of Sumter was looted by Federal troops over two days in April 1865 after Lee's surrender. Skirmishes occurred at Dingles' Mill, Beech Creek, Dinkins' Mill, Statesburg and Oakland Plantation. In fact, the last Federal officer to die in battle in the Civil War died at the skirmish at Boykin's Mill. The county is also known for the High Hills of the Santee and for the fact that part of Lake Marion is located in the

county. The county is also home to the largest F-16 combat wing, the Twentieth Fighter Wing, in the United States Air Force, based at Shaw Air Force Base.

Sumter County has ties to four different governors, two of whom share a name. Those two are Richard I. Manning I and III. Richard Manning I served as governor in the 1820s and was father of another governor, John L. Manning, and grandfather of his namesake. Richard Manning III served as the governor of South Carolina during the duration of World War I. Franklin J. Moses, who was famed for having personally lowered the U.S. flag over Fort Sumter in 1861, served as governor during Reconstruction. Decisions like integrating the University of South Carolina and using state funds for personal use led to his defeat. He left the state for Massachusetts after his term and served time in state prison there for petty theft. Another governor with Sumter County ties was George McDuffie, who also served as a U.S. senator. He is buried in Sumter County but was born in Georgia. The other senator from Sumter County was the county's namesake, General Thomas Sumter. At his death in 1832, he was the eldest native-born surviving Revolutionary general, as well as the oldest living U.S. senator, though he was not in office at his death. His nickname, "the Gamecock," has since been adopted by the University of South Carolina's athletic teams. Sumter led the fight to have the state capital relocated to near his home in Statesburg in 1786, losing by a few votes to Columbia. Another noted political figure from the area was Joel R. Poinsett, U.S. minister to Mexico and namesake of the poinsettia.

Other notables with Sumter County ties include nine-time NBA All-Star Ray Allen and fellow NBA player Pete Chilcutt, as well as NFL players Freddie Soloman, Terry Kinard and Cleveland Pinkney. Ray Allen also costarred in the 1998 Spike Lee film *He Got Game*. Musicians with Sumter ties include Ray "Stingray" Davis, bass singer for Parliament and Funkadelic, and Bill Pinkney, a member of the Drifters in the 1950s. Jim Clyburn, House

majority whip and third ranking Democrat in the U.S. House of Representatives, is a native of Sumter, as was General George Mabry, the second most decorated soldier in World War II and a winner of the Congressional Medal of Honor. Also born here was Bobby Richardson, former baseball coach at the University of South Carolina, seven-time All-Star and three-time World Series Champion with the New York Yankees as a second baseman (including the 1960 World Series MVP award). Richardson ran unsuccessfully for Congress in 1976 as a Republican, losing by about three percentage points despite support from many former major leaguers. The city of Sumter is home to Morris College, a historically black four-year college connected with the Baptist Church, and Swan Lake/Iris Gardens, the only public park in America home to all eight species of swans.

Notable women from the Sumter County area include Angelica Singleton van Buren, the wife of President Martin Van Buren's eldest son, Abraham, and White House hostess for her father-in-law, and Mary McLeod Bethune, founder of what is Bethune-Cookman University in Florida and the National Council of Negro Women. Bethune also served as an informal adviser on civil rights and minority concerns to Presidents Franklin Roosevelt and Harry Truman. Concerning Mrs. Abraham Van Buren, she was never First Lady, as she was not a president's wife, despite the claims of some sources. Charlotta Bass, who became the first African American woman to run for either the presidency or vice presidency when she accepted the nomination of the Progressive Party for vice president in 1952, was born in Sumter. The party finished a distant third with fewer than 150, 000 votes and died shortly thereafter.

Another twentieth-century African American political trailblazer with Sumter County ties was Osceola McKaine. He was the Progressive Democratic Party's candidate for U.S. Senate against Olin D. Johnston in the 1944 general election. He ran to protest South Carolina's defiance of the U.S. Supreme Court's ruling in

Smith v. Allwright that the then-current "white primary" system was illegal. He is officially credited with receiving three thousand votes, but most scholars think he actually got closer to ten thousand votes. Clara Kellogg, one of the first American sopranos to sing as prima donna in an Italian opera house, was also born in Sumter.

THE CHURCH OF THE HOLY CROSS: THE STROLLING GENTLEMAN AND A LADY, SITTING IN A TREE

As mentioned previously, Joel Poinsett, U.S. secretary of war under President Martin Van Buren, is buried at the Episcopal Church of the Holy Cross in Statesburg, South Carolina. Secretary Poinsett also served as a U.S. congressman and as the United States' first minister to Mexico following that country's independence. The church is among the largest rammed-earth construction buildings in the United States and has been a National Historic Landmark since 1973. It is still an active church despite having been built by 1852, so please be respectful during any visits and do not disturb any services or events.

The church cemetery is reputedly the haunt of two apparently unconnected spirits. The first ghost is that of a gentleman dressed in antebellum clothing who strolls between the stones in the cemetery directly behind the church building. I have encountered this ghost briefly. I came around the corner of the building one day while recording some headstone inscriptions and noticed him walking near the brush line at the rear of the property. He paused at my approach and vanished suddenly. Several candidates have been proposed for this unidentified ghost. He may be a Confederate soldier interred in the cemetery; a member of the Frierson family, whose graves were relocated here before the flooding of their burial site in Clarendon County by the waters of Lake Marion in the

1940s; or Secretary Poinsett himself. The figure I saw looked to be in his twenties, so I would venture a guess that the Confederate is the likeliest candidate. Sadly, when my wife Rachel and our friend Erin returned to document sites for this book in the Kershaw and Sumter County areas, we did not receive a return engagement.

The second ghost is a bit too far-fetched even for me to believe. It involves a woman of unknown age sitting cross-legged in a low-lying tree near the front of the cemetery. No clothing details or any other possible identifying marks have come to my attention. On neither visit did I or the two ladies I was with notice anything out of the ordinary, despite our best efforts.

BETHEL UNITED METHODIST CHURCH: TOOK SOME LOOKING

Bethel Methodist Church is located near the Lee County line in the community of Oswego, just north of Scape Ore Swamp, of Lizard Man notoriety. This is the nearest church to what is described online as the Martinville Church on Martinville Church Road, despite the church actually fronting on Lodebar Road. It is the only church in the area and is marked by a South Carolina Highway Historical Marker, having been built in 1856. Witnesses to the haunting state that on a late-night visit in July, singing was heard near the large iron gate that marks the cemetery entrance. Once the witnesses were inside the cemetery, the atmosphere grew heavy and oppressive, like an invisible blanket had been tossed over everything, and lights were seen in the church, which were doused when the group left. I can't testify to this site being haunted, since I merely experienced a small southern church graveyard on my visit, but the experience sounds like a motion detector was triggered. The change in atmosphere and singing, however, I can't explain at all.

OAKLAND PLANTATION

Oakland Plantation near Hagood was the seat of the Sanders family from 1735 to 1981. The first structure on the site was a public house or tavern. The current house dates from 1816 and was built by Williams Sanders IV. In fact, modern Hagood was originally named Sanders Junction, only changing following the election of Johnson Hagood as governor in the 1880s. According to local accounts, the house still stands due to the beauty of the daughter of William Sanders V, Georgia, whose charms so struck Major General Potter that he returned to Hagood after the war to woo her. Sadly, he would be disappointed, as she has already married a local.

Given his role in devastating the Pee Dee and Sandhills area, I doubt his suit would have carried much weight, considering that the house was known as Dixie Hall from the 1950s. Even considering its use as a headquarters for both Major Generals Potter and P.M.B. Young and as a field hospital, the house was still struck by a stray artillery shell. However, the haunting surprisingly has nothing to do with its use as a field hospital. The ghost is supposed to be William Sanders IV, who cut his throat after his favorite daughter married a man of whom he disapproved. He is supposed to have repented with his last breath and still paces about. He is reputed to be the house's protector. Sadly, I cannot verify Mr. Sanders's continued presence, as I could not arrange an invitation to Oakland and did not wish to disturb the present owners.

STAMEY LIVESTOCK ROAD: FIVE IN, THREE OUT?

In the interest of full disclosure, the following could not be verified beyond driving the length of Stamey Livestock Road near Dalzell. Neither I, my wife nor the friend who was with us saw anything

but fields, trees and some scattered houses. Since Booth's Lake is located on private property, we could not visit the actual site. However, if you have kin in Sumter County, you may have more luck and I wish you well. The actual haunting concerns five airmen stationed at nearby Shaw Air Force Base who drove into the pond after a night of heavy drinking in the 1980s. Two of them drowned then. The surviving three returned later to a barn near the pond and killed themselves. Oddly, no method is mentioned in the account. However, witnesses claim to have seen three men walk into the barn late at night but never exit. If you are able to verify this haunting, please let me know through my publisher. I'd love to see it for myself.

SALEM/BLACK RIVER PRESBYTERIAN CHURCH

Salem Presbyterian Church near Mayesville is better known locally as Brick Church and was founded in 1759. The current building dates from 1846 and is built of bricks made on site. The large church library in the session house dates from 1862. The graveyard, which is the focus of the haunting, dates from 1794. In 1867, the former slave members of the church formed Goodwill Presbyterian Church.

The haunting in the cemetery is marked by several phenomena. Roving cold spots and a sense of terror have been reported, as well as the sights of a young boy standing near the cemetery entrance and a lady walking in a hoop skirt near the rear of the building. On my one visit to the site, I had a sense of something watchfully waiting for me while I was there but saw neither boy nor lady. On a hot, muggy July night in the South, a cold spot, either supernatural or by breeze, would have been welcomed, but I felt nothing. I feel the site would repay other visits and that the lore may be true.

WILLIAMSBURG COUNTY

W illiamsburg County was founded in 1804 out of Georgetown County. It was named in honor of William of Orange, who became king of England in 1689 after the Glorious Revolution and reigned jointly with his wife, Mary, until her death in 1694 and then alone until 1702. His reign led to the Hanoverian Succession and, eventually, the American Revolution. Williamsburg County has remained territorially intact since its creation and is bordered by Georgetown, Berkeley, Clarendon and Florence Counties.

Williamsburg County was the birthplace of one South Carolina governor, Robert McNair. He was governor during the Orangeburg Massacre and received one and a half votes for vice president at the 1968 Democratic National Convention in Chicago. Despite the rural nature of the county, it has been the birthplace of one Nobel Prize winner, Joseph Goldstein, 1985 winner for his research into cholesterol and metabolism. The prize was shared with Michael S. Brown. Actor/comedian Chris Rock was born in Andrews, which is located on the Georgetown/Williamsburg County line. Teddy Pendergrass, world-renowned soul singer with several R&B chart toppers and winner of a Grammy in 1989 for Best R&B Vocal Performance, was born in Kingstree, the county seat. He also has four solo nominations in the same category, three of them (and

his win) coming after a car wreck in 1982 that left him paralyzed from the waist down. He has also been a member of the groups the O'Jays and Melvin and the Blue Notes.

Grammy winner Chubby Checker—who was born as Ernest Evans and whose version of "The Twist" topped the charts twice in the early 1960s and was a huge favorite of President and Mrs. John F. Kennedy—was born in the community of Trio. The current Williamsburg County was the only part of South Carolina not garrisoned by the British after the fall of Charleston in 1780, though two battles were fought in the county. One, at Black Mingo, was on the Georgetown/Williamsburg County line. Two churches in the county, Indiantown and Williamsburg Presbyterian, were burned by the British as "sedition shops." The town of Williamsburg (now extinct) was also burned by the British. Williamsburg County was largely left untouched by the Civil War, until it ended in defeat for the Confederacy. During Reconstruction, the leading Republican in the county was Stephen A. Swails, a former officer of the Fifty-fourth Massachusetts Volunteers and Freedman's Bureau agent, who served as mayor of Kingstree and as state senator from the county at the same time. While in the South Carolina Senate, Swails served three terms as president pro tem, holding an office that no other African American has achieved since.

GOOD TO SEE THE KIDS ENJOYING THE HEMINGWAY LIBRARY

Even though Williamsburg County is fairly large and has a long history of white settlement, it was difficult to find any ghost stories in the published histories of the county—that is, until I visited the Williamsburg County Library in Hemingway seeking potential primary sources. There I found Ann Van Emberg, the branch clerk. She told me that the current branch has been haunted by

the spirits of children since it first opened. She reported cold spots moving through the building that seemed to be most prevalent in the children's stacks, as well as seeing children run along the far wall when none were in the building. She also told me that on some days prior to opening she would hear large crowds of people talking, only to find an empty room when she unlocked the door. On my visit, I found a small and rural but still modern library full of patrons, but I found nothing supernatural. Wanda Baxley, the branch manager, denied any reports of ghosts with a giggle and a shiver. I strongly advise you to take an hour or so during your next visit to Georgetown or Myrtle Beach and make a side trip to Hemingway and see for yourself. And try the barbecue.

BIBLIOGRAPHY

ARTICLES

Bridges, Glenn D. "Campus Ghost Hangs Around." *Periscope*, November 8, 1981.

Kemp, Kristina. "Buildings Inhabited By Ghosts?" *Daily Gamecock*, October 31, 2006.

Knauss, Christina. "Columbia's Historic Haunts." *Columbia State*, October 27, 2000.

Patterson, Lezlie. "Ghost Town." *Columbia State*, July 22, 2006.

Rupon, Kristy Eppley. "Camden's Spirits of the Past." *Columbia State*, October 30, 2003.

BOOKS

Barefoot, Daniel. *Haunted Halls of Ivy: Ghosts of Southern Colleges and Universities*. Winston-Salem, NC: John F. Blair, 2004.

———. *Touring South Carolina's Revolutionary War Sites.* Winston-Salem, NC: John F. Blair, 1999.

Barrett, John. *Sherman's March through the Carolinas.* Chapel Hill: University of North Carolina Press, 1956.

Boddie, William Willis. *History of Williamsburg: Something About the People of Williamsburg County, South Carolina, from the First Settlement by Europeans About 1705 Until 1923.* Columbia, SC: The State Company, 1923.

Bostick, Douglas W. *Sunken Plantations: The Santee Cooper Project.* Charleston, SC: The History Press, 2008.

Brown, Alan. *Stories from the Haunted South.* Jackson: University Press of Mississippi, 2004.

Buxton, Geordie. *Haunted Plantations: Ghosts of Slavery and the Cotton Kingdom.* Charleston, SC: Arcadia Publishing, 2007.

Cross, J. Russell. *Historic Ramblin's Through Berkeley.* Columbia, SC: R.L. Bryan, 1985.

Egerton, John. *Speak Now Against the Day: The Generation Before the Civil Rights Movement in the South.* New York: Knopf, 1994.

Ervin, Eliza Cowan, and Horace F. Rudisill, eds. *Darlingtoniana: A History of People, Places and Events in Darlington County, South Carolina.* Spartanburg, SC: Reprint Company, 1976.

Fox, William Price. *South Carolina Off the Beaten Path.* Old Saybrook, CT: Globe Pequot Press, 1996.

Gordon, John. *South Carolina and the American Revolution: A Battlefield History*. Columbia: University of South Carolina Press, 2003.

Graydon, Nell, comp. *South Carolina Ghost Tales*. Beaufort, SC: Beaufort Book Shop, 1969.

Gregg, Alexander. *History of the Old Cheraws: Containing an Account of the Aborigines of the Pedee, the First White Settlements, Their Subsequent Progress, Civil Changes, the Struggle of the Revolution, and growth of the Country Afterwards; Extending from about A.D. 1730 to 1810, with Notices of Families and Sketches of Individuals*. New York: Richardson and Co., 1867.

Hauck, Dennis. *Haunted Places: The National Directory: Ghostly Abodes, Sacred Sites, UFO Landings, and Other Supernatural Locations*. New York: Penguin, 2002.

Heitzer, Michael. *Goose Creek: A Definitive History, Volume II: Rebellion, Reconstruction and Beyond*. Charleston, SC: The History Press, 2006.

Hilborn, Nat, and Sam Hilborn. *Battleground of Freedom: South Carolina in the Revolution*. Columbia, SC: Sandlapper Publishing, 1970.

Hollis, Daniel Walker. *University of South Carolina*. Volume II: College to University. Columbia: University of South Carolina Press, 1956.

Huber, Patrick. *Linthead Stomp: The Creation of Country Music in the Piedmont South*. Chapel Hill: University of North Carolina Press, 2008.

Huntsinger, Elizabeth. *More Ghosts of Georgetown*. Winston-Salem, NC: John F. Blair, 1998.

Ivers, Larry. *Colonial Forts of South Carolina, 1670–1775*. Tricentennial Booklet Number 3. Columbia: University of South Carolina Press, 1970.

Jenkinson, Gordon B. *Homes and People of Williamsburgh District*. Charleston, SC: The History Press, 2007.

Johnson, Clint. *Touring the Carolinas' Civil War Sites*. Winston-Salem, NC: John F. Blair, 1996.

Johnson, Tally. *Ghosts of the South Carolina Midlands*. Charleston, SC: The History Press, 2007.

————. *Ghosts of the South Carolina Upcountry*. Charleston, SC: The History Press, 2005.

Julien, Carl. *Beneath So Kind a Sky: The Scenic and Architectural Beauty of South Carolina*. Columbia: University of South Carolina Press, 1948.

Kirkland, Thomas, and Robert Kennedy. *Historic Camden: Part Two, Nineteenth Century*. Columbia, SC: The State Company, 1926.

Lipscomb, Terry. *Battles, Skirmishes, and Actions of the American Revolution in South Carolina*. Columbia: South Carolina Department of Archives and History, 1991.

Manley, Roger. *Weird Carolinas: Your Travel Guide to the Carolinas' Local Legends and Best Kept Secrets*. New York: Sterling, 2007.

McNeil, W.K., comp. and ed. *Ghost Stories from the American South.* Little Rock, AR: August House, 1985.

Montgomery, Rachel. *Camden Ghost Stories and Legends.* Camden, SC: 2000.

Orvin, Maxwell Clayton. *Monck's Corner, Berkeley County, South Carolina.* 1950.

Rhyne, Nancy. *More Murder in the Carolinas.* Winston-Salem, NC: John F. Blair, 1990.

————. *Voices of Carolina Slave Children.* Orangeburg, SC: Sandlapper Publishing, 1999.

Roberts, Nancy. *The Haunted South: Where Ghosts Still Roam.* Columbia: University of South Carolina Press, 1995.

————. *South Carolina Ghosts from the Coast to the Mountains.* Columbia: University of South Carolina Press, 1983.

Rose, Mrs. Arthur Gordon. *Little Mistress Chicken: A Veritable Happening of Colonial Carolina.* Washington, D.C.: Colonial Dames of America, 1993, reprint.

Smith, Beth Laney. *The Voices of Pageland: Stories of a South Carolina Town.* Charlotte, NC: Laney-Smith, 1997.

South Carolina Biographical Dictionary. New York: Somerset Publishers, 1994.

Spaeth, Frank, comp. and ed. *Phantom Army of the Civil War and Other Southern Ghost Stories from the Files of Fate Magazine.* Edison, NJ: Castle Books, 1997.

Stauffer, Michael. *The Formation of Counties in South Carolina.* Columbia: South Carolina Department of Archives and History, 1994.

Sumter, John R. *Some Old Stateburg Homes and the Church of the Holy Cross.* Sumter, SC: Sumter Printing, 1949.

Sumter, Thomas. *Stateburg and Its People.* Sumter, SC: Sumter Printing, 1949.

Taylor, Troy. *Field Guide to Haunted Graveyards: A Research Guide to Investigating America's Haunted Cemeteries.* Alton, IL: Whitechapel Productions Press, 2003.

Thomas, Reverend J.A.W. *A History of Marlboro County with Traditions and Sketches of Numerous Families.* Atlanta: Foote and Davies, 1897.

Todd, Caroline, and Sidney Wait. *South Carolina: A Day at a Time.* Orangeburg, SC: Sandlapper Publishing, 1997.

Turnage, Shelia. *Haunted Inns of the Southeast.* Winston-Salem, NC: John F. Blair, 2001.

Wiggins, Carley. *Remembering Dillon County.* Charleston, SC: The History Press, 2008.

Workers of the Writers' Program of the Works Progress Administration in the State of South Carolina. *Palmetto Place Names: Their Origins and Meanings.* Columbia: South Carolina Educational Association, n.d.

————. *South Carolina: A Guide to the Palmetto State.* New York: Oxford University Press, 1941.

————. *South Carolina Folk Tales: Stories of Animals and Supernatural Beings.* Columbia: South Carolina Educational Association, n.d.

PERSONAL INTERVIEWS

Baxley, Wanda. Branch manager, Hemingway Branch of the Williamsburg County Library. January 24, 2009.

Edens, Lou. Owner, Rice Hope Plantation Inn, Monck's Corner, South Carolina. November 19, 2008.

Quist, Donald. Employee, Charles W. & Joan S. Coker Library/ Information Technology Center, Hartsville, South Carolina. January 17, 2009.

Steen, Charles. September 5, 2008.

Van Emberg, Ann. Branch clerk, Hemingway Branch of the Williamsburg County Library. January 24, 2009.

BIBLIOGRAPHY

WEBSITES

Account of Potter's Raid, 54th Mass. http://www.awod.com/
gallery/probono/cwchas/potter.html.

Archdale Hall. http://home.earthlink.net/~copeland.deal/
archdale_hall.htm.

Big Bend Ghost Trackers—Strawberry Chapel. http://
bigbendghosttrackers.homestead.com/files/strawberry.html.

Book by J.O. Moseley Concerning the Schoolhouse Fire. http://
clevelandschoolfire.com/jomosley.htm.

Cleveland School Fire. http://www.scarboroughgenealogy.com/
Cleveland.htm.

Florena Budwin. http://home.att.net/~florencestockade/florena.
htm.

Ghostlights. Bingham Light, Dillon, South Carolina. http://www.
ghosts.org/ghostlights/bingham-light.html.

The Ghost of Bingham's Light in South Carolina. http://www.
unsolvedmysteries.com/usm71277.html.

Haunted Hotel Room Keeps Low Profile. http://www.
roadsideamerica.com/news/16864.

Haunted Libraries in the U.S.: Pennsylvania—Texas. http://www.
britannica.com/blogs/2007/10/haunted-libraries-in-the-us-
pennsylvania-texas.

Haunted Places Report. http://www.haunted-places.com/ HRvol2a.htm.

Historical Background of Potter's Raid. http://pottersraid.tripod. com/historicalbackground.html.

Madeline. http://www.golarry.net/RGS/MADELINE.txt.

The REAL Crybaby Creek Bridge—Strange Carolina Tales. http://strangetalespodcast.wordpress.com/2007/05/28/the-real-crybaby-creek-bridge.

Salem Black River Church—The Southern Belle Ghost. http:// trueghosttales.com/stories/southern-belle-ghost.php.

SCRoots. Forgotten Graveyard of Mount Parnassus. http:// homepages.rootsweb.ancestry.com/~scroots/m_parnassus. html.

Shadowlands Haunted Places Index—South Carolina. http:// theshadowlands.net/places/southcarolina.htm.

The Songs of Dorsey & Howard Dixon. http://www.fortunecity. com/tinpan/parton/2/dixon.html.

South Carolina Historical Markers Associated with the Civil War, 1936–Present. http://sc150civilwar.palmettohistory.org/ civilwarhistoricmarkers.pdf.

South Carolina SC Plantations. http://south-carolina-plantations. com.

BIBLIOGRAPHY

Southern Ghost Stories. http://southcarolinaghost.tripod.com/ GhostStories.

Summerville Light. http://castleofspirits.com/summerville2.html.

Sumter Ghost Finders—Sumter, South Carolina. http://www. sumterghostfinders.com.

The Third Eye Man. http://www.midnet.sc.edu/ghost/ ThirdEyeMan.htm.

Welcome to Strangeusa.com! Bingham's Light. http://www. strangeusa.com.

ABOUT THE AUTHOR

Tally Johnson has been fascinated by the rich ghost lore of his native South Carolina for almost thirty years. Born in Lyman into a family of readers, his interest in ghost stories was first piqued by a presentation by author and storyteller Nancy Roberts given to his fifth-grade class at Lyman Elementary. As he got older, he visited many reputedly haunted sites throughout the Carolinas and Georgia. He had enough encounters with various manifestations to convince him that ghosts do exist. He has a library of over one hundred books of ghost stories, and he noticed that the ghost lore of inland South Carolina had been neglected for too long.

Mr. Johnson is a graduate of Spartanburg Methodist College and Wofford College with degrees in history. Following work toward his MA in history at Winthrop University, which he just missed completing before real life intervened, he became the local history coordinator at the Chester County Library. As part of his outreach to local schools and in response to repeated prodding by

his wife, Rachel, he began telling students about his experiences with ghosts. After repeated complaints about poor writing and a lack of local lore in the books of ghost lore that he bought, his friends challenged him to write a book that would meet his standards. *Ghosts of the South Carolina Upcountry*, his first book for The History Press, was the result. *Ghosts of the South Carolina Midlands* soon followed, due to several reader requests. Mr. Johnson currently serves as branch manager for the Great Falls branch of the Chester County Library and is active in many community groups, including Chester County First Steps, the School Improvement Council for the Chester Park School of the Arts and the Chester Little Theatre among others. He is on the Roster of Approved Artists as an author, as well as the South Carolina School Librarians' list of storytellers. He is a former member of the South Carolina Archival Association; Palmetto Archives, Libraries, and Museums Council on Preservation (PALMCOP); Phi Alpha Theta (the graduate history honor society); and the South Carolina Storytellers Association. He enjoys spending time with his family and friends, hiking and visiting historic sites, and he is a voracious reader.

ALSO AVAILABLE

978.1.59629.057.0 • 96 pp. • $17.99 978.1.59629.200.0 • 96 pp. • $17.99

Visit us at

www.historypress.net